Hybrid Prints

Hybrid Prints

'To infinity and beyond!'

MEGAN FISHPOOL

A & C BLACK • LONDON

Dedication

This book is dedicated to my dearest Peter and Grace, Lisa, Tricia,
my Mum and my Dad. Life without you would be like a broken
drypoint needle … pointless.

First published in 2009 by
A & C Black Publishers Limited
36 Soho Square
London W1D 3QY

www.acblack.com

ISBN: 978-0-7136-8650-0

Copyright © 2009 Megan Fishpool

CIP Catalogue records for this book are available
from the British Library and
the U.S. Library of Congress.

Copyeditor: Julian Beecroft
Commissioning Editor: Susan James
Managing Editor: Sophie Page
Designer: Jo Tapper

This book is produced using paper that is made
from wood grown in managed, sustainable
forests. It is natural, renewable and recyclable.
The logging and manufacturing processes con-
form to the environmental regulations of the
country of origin.

Printed by C&C Offset Printing Co Ltd., China

Frontispiece: Halftone aquatint dot screen.

CONTENTS

Acknowledgements

This book would not be possible without the support and effort and artworks contributed to it by my colleagues and fellow artist friends, who not only inspire me on a daily basis, but continue to provide the reasons and incentives for why I make prints and teach others how to make them. In particular, I would like to thank my colleagues at Artichoke, Melvyn Petterson and Colin Gale, who have created a phenomenal environment for printmaking and artists who love printmaking.

Making prints and the enthusiasm for printmaking are what ensures that printmaking is a vital, positive and energetic creative medium, which will continue to push forward the ways artists have always used to make prints and the ways undiscovered with which they will make prints in the future. Thank you to all the artists who provided me with photos and digital images of their work for use in this book, and thank you to Susan James at A & C Black for giving me the opportunity to write this book.

INTRODUCTION

■ Printmaking provides unending, infinite opportunities for image-making. The materials, tools and processes available to the printmaker only reinforce what the medium of printmaking has to offer. Using this vast array of printmaking tools, equipment and techniques is what creates the situations in which hybrid prints or combination prints occur.

The printed image is driven forward by ever-evolving industrial, digital and technological developments, along with the printmaker's own ingenuity, curiosity and passion for discovery. In 1953, the artist-engraver John Buckland-Wright wrote in his book *Etching and Engraving Techniques and the Modern Trend*, The Studio Limited, London, 'Contemporary vision and expressionism often require more means than are offered by one individual technique. The tonal processes of aquatint and soft-ground etching, etc. are improved by, and in fact require, as a rule, the decisive element offered by drypoint, etching or line engraving to make them truly expressive. It is natural, therefore, to employ any and every means at the artists' disposal to achieve the artists' end'. He called this chapter in his own book, *Combined Processes*. Fifty-five years on, the media of hybridizing printmaking is alive and well.

Combination or hybrid printmaking is printmaking at its most innovative, dynamic and inquisitive. The best way to make prints is to find the means and processes best suited to your needs. Technical processes are there to inform us and to be used as they are intended to be used, but also, because of our natural desire to innovate, they also provide a set of rules that we can challenge, question and explore.

The best way to create the image you want to make is to use not just one printmaking technique but a combination of techniques. Combining one printmaking technique with another creates a combined (or hybrid) print. A combination of techniques can result in a printmaking form that becomes a standard technique – two techniques interacting with each other to become a single tool or material that other printmakers might then find useful.

This book uses pictorial references and hands-on demonstration sequences to consider how the combined print has established itself as a printmaking medium, though of course it would be impossible to document every technical combination in this brief handbook. Equally important, however, it reflects upon the idea of creativity, for without that factor any making process risks becoming a mere chore.

Where the medium of printmaking excels is in being capable of going beyond the rote of technical process. If we step through the various techniques to the other side – the freedom of knowing your craft and taking pride in that skill – then it is capable of capturing what we see in our imagination and making it real.

WHAT IS HYBRID?

Hybridisation takes place, and flourishes, to exploit new niches that appear in existing environments, processes and tools. When two techniques interact with each other to become a single tool or material, you have a hybrid or combination.

The process of combining two elements together can be endlessly refined, sometimes with seemingly small changes in what is being combined, but still totally necessary ones for achieving the desired end result.

In certain situations a species is forced to evolve because survival favours the characteristics of the new species above those of the old. In certain creative situations, visualization is the vital motive in the combinations that occur

 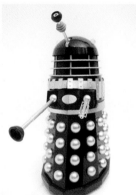 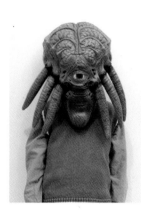

George is combined with a Dalek. A hybrid results – a Dalek Sec.

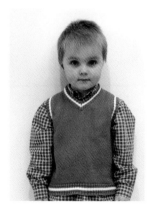 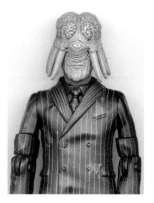 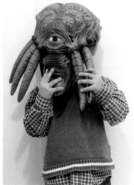

Albert is combined with a Dalek Sec. A hybrid results – a different Dalek Sec.

Opposite: The ballrack in use at Artichoke Print Studio, 2008.

between processes or techniques or in the use of tools; because the need to make a tool or process to give you your desired result will drive you to improve or change the existing version.

In the case of the Daleks illustrated here, the improved species will take over the world. In the printmaking environment combinations of processes, techniques and tools solve creative dilemmas and stimulate new ideas (and possibly take over the world!).

The idea that there has always been another way has existed most definitely since humans began having great ideas. In 1853, Victor Hugo summed up an eternal sentiment in the pithy statement, 'Necessity is the mother of invention'. If we go back to the year 287BC, Archimedes gave us an even better one: 'Eureka!'

Combination printmaking can be described as being a combination of both necessity and eureka. When did the first combination in printmaking occur? Was it a monoprint? Was it a scraper-burnisher tool? What could possibly have been the first moment of combination in printmaking?

A HYPOTHETICAL COMBINATIONAL MOMENT IN PRINTMAKING

The printing press

The year 1450 is when Johannes Gutenberg invented the first printing press with moveable type. But how did he come up with the idea? We can try and imagine how, given the existing elements he had available to him to combine. Hypothesis: The combination of moveable type and a wooden screw press created one of the most simple and practical machines of his time, which has evolved into one of the most integral and iconic printmaking tools that the printmaker uses – the printing press.

The earliest-known screw press (the forerunner of the nipping press) was made by the Greeks over 5000 years ago. The working function of the screw press was to apply pressure to separate an ingredient from a solid material – for example, in turning grapes into wine.

Engraving, woodblock printing and the handwritten manuscript were the heavyweight printmaking techniques of the thirteenth century. Engraving was used to inscribe and decorate coins, jewellery, weapons, musical instruments, ceramics, banknotes and stamps, and has existed since the 1st millennium BC. The earliest woodblocks/cuts date from 220BC in China. When a woodblock is hand-printed, pressure placed on the surface of the inked block transfers the ink from the surface onto the paper.

Given this hypothesis, we can begin with the engraved marks on the copperplate or the text of a handwritten page of manuscript. If each individual mark were to be freed so that it could be used and reused again where and when needed, then eureka!

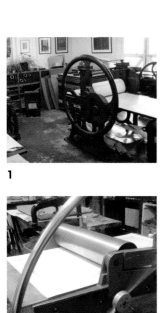

1

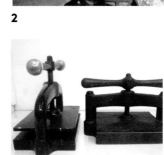

2

1 The Harry Rochat fixed-roller press at Artichoke Print Studio.

2 The Haddon fixed-roller press at Artichoke Print Studio.

3 Karsten Berglin press, a sprung-roller press used at Artichoke Print Studio, ideal for all printmaking techniques – relief, lithography and intaglio.

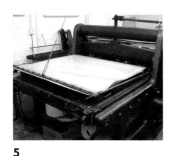

3

4

4 Nipping presses. Great for small-format block printing/relief blocks.

5 Motorised Mann direct litho press, Artichoke Print Studio.

6 Offset litho press at Artichoke Print Studio.

5

6

7 Stone lithography direct press at Artichoke Print Studio.

8 The Albion press, courtesy of Gail Porter, Half Moon Studios, London.

7

8

Combine the idea of a copper engraved text and the idea of the raised text in relief on a woodblock and we are on the way to moveable type to create text. Combine the wooden screw press with a mobile matrix with a raised surface covered in ink and we arrive at the forerunner of the printing press.

This is only a hypothetical combination of printmaking elements, but it is still an important one. I am trying to illustrate here that combinations are the very fabric of printmaking and that traditional printmaking methods combine readily and easily with new technologies no matter what century the printmaker is working in.

There is a lovely story, recounted by Ann Maley, in *What is a Tessellation?*, Wall Quiet Gallery, annmaley.com, 2007, about the invention of the potato print by the Dutch artist M.C. Escher. 'Escher, invented a design game to play with his young son, George. He cut a potato in half, which was carved and printed in the same way a linoleum or woodblock is carved and printed. The potato was then shaped into a square, and lines were drawn across it so that the ends of each line touched a corner of the square or the midpoint of a side. The potato could be turned in various orientations, according to certain rules, and printed repeatedly, to create a network of lines with its own symmetry and rhythm.'

He could not have known that the humble potato would go on to enjoy a long and successful career in the world of printmaking. For many of us, it is our first introduction to the idea of what a print is. And all because of the idea of combining the making of a relief print with an unlikely matrix.

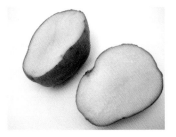

Potato cut.

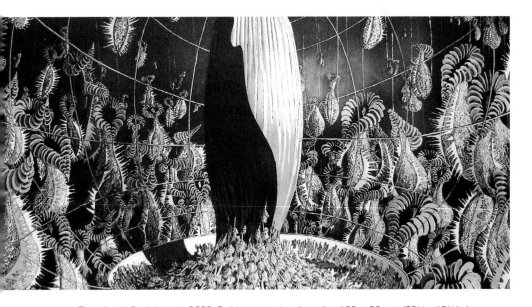

Titan Arum, Ruth Uglow, 2005. Etching, aquatint, drypoint, 100 × 50 cm (39½ × 19¾ in.).

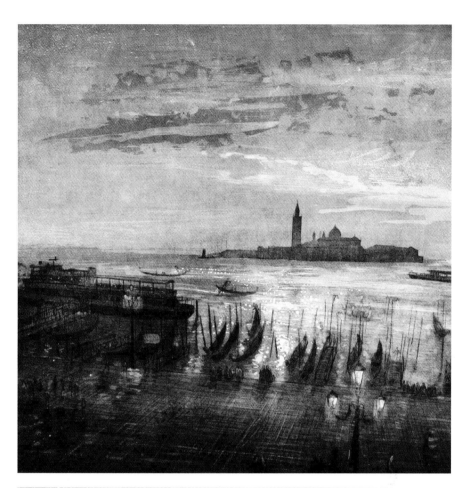

Venice, David Gluck, 2006. Aquatint and etching, 76 × 92 cm (30 × 36¼ in.).

Of a Natural Progression, David Smith RE, 1992. Photolitho, 41 × 135 cm (16 × 53 in.).
Collection of the Hawaii State Foundation on Culture and the Arts, and private collections.
The artist says of this print that it was influenced by the death of a very close friend, and that
it was exclusively drawn on zinc plate and finished with images exposed onto photoplates.

HEALTH AND SAFETY

The most dangerous health and safety risk in the printmaking studio is the printmaker themself. What you do in the studio creates health and safety situations.

The number one most important health and safety rule is common sense. Common sense says if it smells like something is burning, something probably is. If it is too heavy to lift, ask for help. If you don't think you should be doing something, don't do it. In most open access studios you are not allowed to change or mix acids or adjust the pressure on presses. The studio manager does this. There is a reason for this. They know how to do it exactly as it should be done.

Health and safety rule number two is 'If you do not know' ASK. How, what, when, who or why, – if any of these 5 words begin one of your thoughts when making a print – apply rule number two. With these two stalwart tenants always in mind you will spend many pleasant and creative hours in the printmaking studio.

In the printmaking studio, taking care to use all of the appropriate protective measures when using chemicals, solvents, acids, presses and power tools is important. Protective clothing should always be worn; apron, gloves, eye goggles and respirator mask. Wearing these all at the same time is personal to the individual printmaker, and is usually dependent on the task being undertaken. These items are always worn when acids, chemicals and caustic are used.

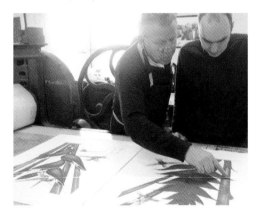

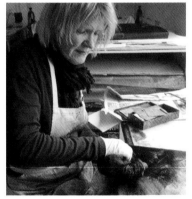

Working in a printmaking studio involves discussions about many things; how to make an image, what technique is suitable, or having a knowledgeable and skilled professional printmaker produce a plate and print for you.

Protective clothing should always be worn; this is personal to the individual printmaker, and is usually dependent on the task being undertaken.

Machinery and Equipment/Acids and Solvents

The printmaking studio is an intriguing environment. Fascinating equipment and exotic sounding materials are found in use with formidable machinery and solvents and chemicals which will make you wish you really had paid more attention when you did chemistry at school! All of these elements combine together to make any of the printmaking techniques the printmaker chooses to use, perform to it's best capability.

Copper, zinc, steel and aluminium are the main metals the printmaker uses. Learn to handle machinery such as the large foot treadle guillotine with confidence. Guillotines not only cut plates into right angles, squares and rectangles, but also can be used to create multi-sided plates or unusual geometric shapes.

Power tools and presses involve using physical strength, hand and eye coordination, good posture and balance.

Acids serve a significant and vital purpose in both intaglio processes and lithographic processes. Used correctly and safely, they play a major role in how an image is evolved on metals. Nitric acid is used for steel and zinc. Ferric chloride is used for copper and aluminium. The appropriate acid proportion is added to the water to make the appropriate strength of the diluted acid. It is necessary to give a gentle, controlled, timed bite to the image marks made on the plate.

Learn to handle machinery such as the large foot treadle guillotine with confidence.

They are used in covered trays in fume cupboards with extractor units in place to draw away fumes and odours. All solvents, chemicals and acids are stored in locked, fire-proof cupboards in the printmaking studio.

Solvents such as white spirit and methylated spirits serve an equally important role in resolving how many things are cleaned in the studio. Aquatint resin is removed using methylated spirits (denatured alcohol). It has a distinct odour and feels like very cold water on the skin. Gloves should be used when handling it. White spirit removes wax and liquid grounds and printing inks.

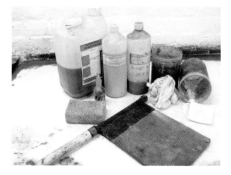

This picture shows some of the solvents and acids used in lithography: synthetic gum arabic, nitric acid, atzol, victory etch, resin, chalk, natural sponge, drying flag.

Acetic acid smells like vinegar and should be diluted to a ratio such as 20:1 when used. It is used to clean newly etched lines during the biting process for easier viewing of the image on the plate. Ammonia and caustic are two other chemicals found in the printmaking studio. Diluted ammonia (20:1) is used to degrease metal plates and caustic is used to etch lino and also to remove hardened photo emulsions from metal plates; goggles, gloves and a suitable dust mask should be worn.

There are many new chemically friendly cleaners such as citrus-based cleaners (available from Intaglio Printmaker, see suppliers) and acrylic polymer cleaners such as Mr. Muscle (heavy duty kitchen cleaner available at any supermarket). They are suitable for cleaning glass tops, all printing inks, screens and plates.

Becoming familiar with materials used in different processes means that you understand why and how a technique can be used successfully. It also allows you to correct mistakes with confidence or save an image rather than call it quits when something goes completely wrong. A good studio is a user friendly environment. Everything in a printmaking studio suggests artistic activity and community. Printmaking is a hands-on activity, and you express yourself through the use of an exciting range of materials and equipment. Seek advice if you do not understand something or if a health and safety issue concerns you.

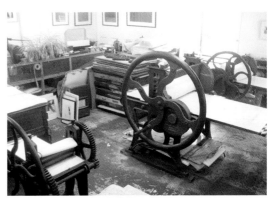

Knowledge about printmaking materials and equipment can be sourced outside of the printmaking studio. Intaglio Printmaker is an outstanding printmaking supplier based in London SE1.

A good studio is a user friendly environment. Everything in a printmaking studio suggests artistic activity and community such as in the picture here of Artichoke Printmaking studio in London SW9.

DIGITAL PRINTMAKING: THE INTEGRATION OF DIGITAL INTO PRINTMAKING

How advances in technology combine with printmaking

An integrated digital combination print can be said to be made up of both digital elements and traditional printmaking techniques. But it can also be made with combined digital-software programs. Indeed, the range of digital equipment and software programs now available can allow the printmaker to work with purely digital elements to create a print.

If we break down this idea, we can begin to understand how far printmaking has progressed as a multifaceted and inspiring world of creative options for the printmaker. Digital means far more than just an A4 inkjet image printed onto a sheet of inkjet photo-quality paper.

Using digital technology presents new ways of using hands-on traditional printmaking processes. I love drawing my images directly onto a hard-ground

Untitled, Barton Hargreaves, 2007. Digital installation and print using Photoshop management colours, Epson Pro 11880 EMP-MK, roll paper (enhanced matte).

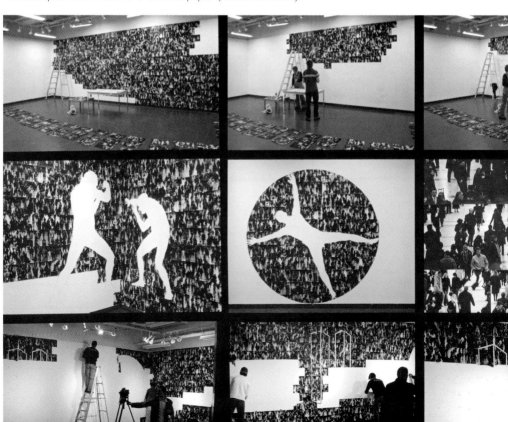

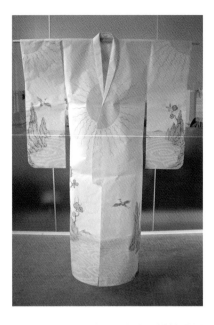

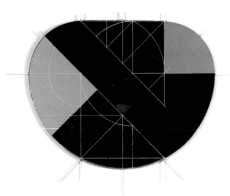

Above: *Kimonon*, Magnus Irving, 2003. Digital textile, 168 × 132 × 56 cm (66 × 52 × 22 in.).

Right: *Golden Section*, Steve Hoskins, 2006. Digital Screenprinting construction 56 × 76 cm (22 × 30 in.).

Untitled, Colin Gale, 2007. Digital Etching, 16.5 × 13.5 cm (6.5 × 5 in.).

wax on an etching plate, or drypointing directly onto a plate. The extended process of working the surface and seeing changes take place with each proof that is pulled from the plate is tantalising and exciting. Nothing can match the thrill of pulling the printed proof away from the fully inked plate to reveal the image for the first time. The sensation of 'wait for it!' is still the same now as it was the first time I did it. Rendering things by hand in layers takes time, but is totally absorbing when you are involved in getting a printmaking technique to give you the result you want.

Equally, I am fascinated by the innumerable ways that an image can be manipulated literally instantaneously before your eyes when using image-manipulating software programs. You can effect innumerable visual changes and combinations at one sitting, saving each 'layer' as you go, to be returned to again and again for reference. In the long run, it's as quick as using a sketchbook.

Traditional processes have been absorbing digital processes quite seamlessly for many years now. Our printmaking repertoire is enriched by many of them, and in some cases is made to suffer where people misunderstand that the kinds of instant processes offered by many commercial printing outlets have nothing to do with hand-crafted printmaking processes, even when digital techniques are involved. What printmaking has always understood best is how to balance that use of time – the quick efficiency of commercial attitudes set against the glorious step back in time evoked by traditional printmaking techniques.

BASIC INTRODUCTION TO DIGITAL INTEGRATION PRINTS

Digital integration prints always involve making a positive or using digital software if the computer itself is the substrate. This is the crux of the integrated digital-printmaking image.

Digital in the simplest form employed by printmakers entails the use of a positive. A positive can be either a photocopy, an acetate or a stochastic (in this case a mathematical formula for producing random halftone dot patterns). Paper positives can be either inkjet prints or photocopies for transfers to photolitho plates or photo-etching plates.

What is the halftone screen?

Halftone dots are the information that make up your final, outputted image. Your picture on the computer screen is made up of a certain number of pixels (points of illumination). The fewer pixels that comprise your screen image, the poorer it is in quality and clarity of detail. It may still look good to your naked eye, but there will not be enough information there to translate into

Random dot screen.

the detail and accuracy that the halftone dot requires. This quality is called the image's resolution or dpi (dots per inch).

What is a dither?

Continuous tone must be broken down into the elements of single colour by half-toning or dithering. In classic photography halftones, dots vary in distribution rather than in size. So dithering compensates for this in the digital image by being a random distribution of dot size to mimic the photographic halftone.

What is an emulsion-reading image?

This is the image-bearing surface that needs to be in contact with the light-sensitive emulsion side of the plate.

What is screen-ruling?

The frequency and resolution of an image, screen-ruling varies according to each different printmaking technique to which it applies, namely etching, litho and screen-printing. This is because different positives need different exposure times, known as units of light. A photocopy on paper or a drawn image on drafting film will require more time or units of light than a transparent positive or acetate.

Multi-layer images for outputting in Photoshop® need registration marks on each layer to ensure identical positioning.

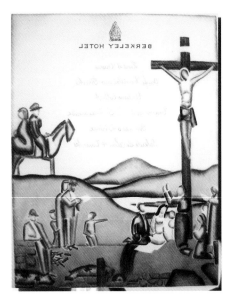

Untitled, John Kindness, 2007. Flexo-plate photo-etching, 50 × 64.5 cm (19.5 × 25 in.). The illustrations show two of the three positives used in the final image: the brown areas of the image, which were printed first; and the blue areas of the image, printed second. A third colour is not shown, while the grey areas were printed last. The image was made on three flexo-plates.

These are acknowledged halftone-screen dpi for the following printmaking processes:

Etching	halftone from 100 to 200 dpi
Photo-litho or photo-offset litho	100 to 150 dpi
Screen-printing	100 to 150 dpi

What gives you the best image resolution?

The quality of the original source material, the device used to output the positive, and the tonal range resulting from those two combined are what will give you the best results for the images you want to create.

Is a digital print autographical?

Prints can use traditional printmaking techniques that include digital elements or not. An original print with or without digital elements is autographical. The human hand renders both of the images. The point of departure that confuses is that for one you hold an etching needle and for the other you hold a mouse.

Digital print, Stephen Mumberson RE, 2002. Digital image using Photoshop®, 15 × 8 cm (6 × 3 in.).

Left: *Circus Performer*, Sandra Millar, 2004. Etching, aquatint and *chine collé*, 48 × 36 cm (19 × 14 in.). A digital image is made up of pixels and vectors. It is created using digital-software programs and input and output equipment. The image on the left is made by drawing directly on the plate.

Right: *Untitled Maroon*, Randal Cooke, 2007. Digital print, 30 × 42 cm (12 × 16.5 in.).

Understanding the image on your computer screen

Pixels are tiny areas of light on a screen that collectively make up an image. All computer images are made up of pixels. The screen image is an area or quantity of light that has direction as well as magnitude. Until you output your screen image via a printer, the image on your computer screen is only organised light.

Turning organised light into prints

Above: *Greeks*, Stephen Mumberson. Digital print. 15 × 8 cm (6 × 3 in.).

Left: *Shithouse*, Matthew Weir, 2007. Photo-etch/aquatint. 20 × 15 cm (8 × 6 in.).

 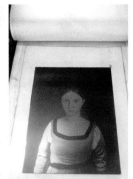 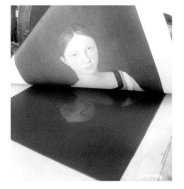

Hester, Richard Wathen, 2008. Colour positive, flexo-plate, final print before hand colouring. 71 × 55 cm (28 × 21.5 in.).

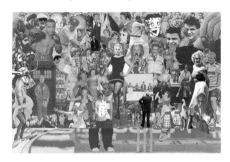 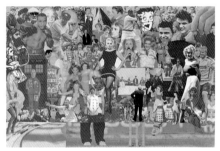

Have a Nice Day Mr Blake, Megan Fishpool/Peter Blake, 2007. Original collage, grayscale positive. Created specifically to be an etching for Peter Blake. 52 × 32 cm (20.5 × 12.5 in.).

Cranes, Simon Lawson, 2008. Photo-etching. 56 × 76 cm (22 × 30 in.).

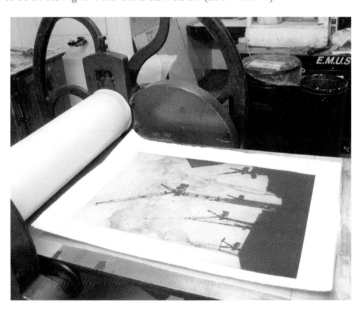

INTEGRATED DIGITAL COMBINATION PRINTS

The following sequence shows a stereolithographic woodcut being made. The artist Jason Oliver, printmaking tutor at the Royal Academy Schools, combines two techniques to arrive at a distinctly familiar end result.

In this hands-on demonstration, the artist is using the software program Modo, though there are other similar programs such as 3DS MAX™, Maya™, Blender™, Bryce 6™, VRML™ and Truespace™ that may better suit another artist's needs. Jason uses Modo for its simplicity and the ease with which the

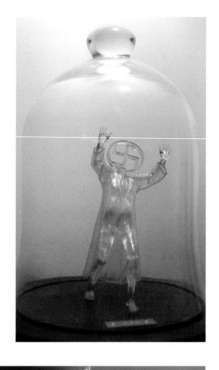

'XPR' Kefra, Jason Oliver, 2007. Digital Print, 25 × 30 cm (10 × 12 in.).

Four computer-screen views of *The Subtle and the Gross,* Jason Oliver, 2007. 11MB.

tools within the software itself can be manipulated to create imagery; in his own words, 'the mark-making act becoming intuitive and second nature, rather than a struggle'. Learning to handle any type of printmaking tool, be it a drypoint needle, etching needle, roulette, aquatint resin or software program, to use in the creation of an image, is vital, of course, to the mark-making act becoming intuitive or second nature. Imagine if we still had to stop and think about how we breathe or tie our shoes. Every artist strives for the same fluidity of use with the tools associated with the particular printmaking technique they are practising.

Jason remarked that sometimes familiarity can lead to complacency, that as artists we sometimes stop connecting with our tools when the marks they make cease to stimulate us. This is true for digital tools as well. So how do we keep it all lively and interesting?

Combinations are a brilliant way to achieve the unexpected, to discover alternatives and stimulate new ideas.

The following sequence shows a 3D model being made on the computer screen in preparation for outputting to a rapid-format prototype printer. The output will be transferred onto a wooden block to be used for a woodcut.

Building a stereographic print

1. *The blank.* First, the artist starts with a blank space. The best way to describe this blank space is as an empty stage or an empty room. The space on the screen has height, width and depth.

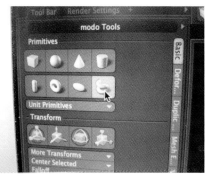

2. *Primitives.* Second, the artist selects the primitive(s) that is/are needed to build the image. Primitives are best described as building blocks. Say we are going to build a 3D structure of flowers in a vase. Everything that takes up physical space has volume. These primitives represent all the basic shapes through which physical volume can be expressed: cone, sphere, pyramid, cube, doughnut, teapot, cylinder, spiral, etc.

3. *Search.* Once the primitives are selected, you need to locate them in the actual spatial plane. A camera icon appears and you can literally visually zoom around in the picture plane on your screen – for example, move to the background, the foreground, the middle ground, to the left and right sides, up and down. This gives you a feel for how the image is placed in your screen space.

4. *Smooth shift.* With a base primitive in place the artist can start applying geometry, that is, the arrangement of the parts of something for example, the surfaces, solids, lines and points and their relationships with each other. Of course, geometry, as well as being applied, can also be taken away. In the first picture, the shape of the original primitive (the capsule shape) is duplicated and placed inside it. The solid shape that it appeared to be now appears hollow (second picture).

5. *Slice.* Slicing is a way of cutting the image in half. If you imagine a potter's wheel and on it is a ball of clay, the slice effect is like taking a cutting wire and slicing the ball of clay in half. This way you can make cuts of any angle and size – so you literally sculpt your image by cutting it away. In this image the slice looks like a flat grey plane. Imagine that this flat plane is made of glass. The same as the cutting wire cutting through clay, the plane of glass is cutting through the object on the screen.

a

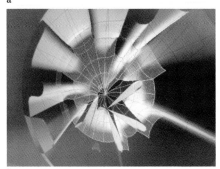

b

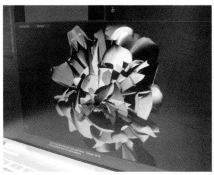

c

6. (a, b & c) *Bevel.* Bevelling a 3D image is a way of layering it to create depth. This is very similar to the tonal values you achieve on an etching plate when you use different biting times in the acid. Bevelling or making layers adds even more definition to the image being created. In picture 6a, the yellow wire structure on the image highlights the areas of the image in which varying areas of depths are being made to appear. To further explain what is happening when bevelling is being applied to the image we can use the example of layers as they are used in the software program Adobe Photoshop®. A Photoshop® image is made up of as many layers of image information as you need to create a final image. You can rearrange, take away or add to these layers to achieve the final, fully formed image. The main difference is that the Photoshop® image remains distinctly 2D.

6. (d & e) *Bevelling* literally encases the structure in a visual wire frame. The structure of the base primitive is made up of innumerable individual polygons that can be individually moved around. So in the process of bevelling, the polygons are pushed forward and back to different heights, creating depth on the surface of the image. Picture 6d shows the yellow wire frame tool removed from the image. The image appears to have shape and form now. We can see the variation in tonal values that has been created in the image.

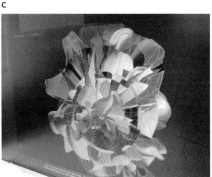

d

e

7. *Thicken.* Thickening is when you give the image 'surface'. The best way to describe surface visually is to say it is like giving the image we have created skin. This outer skin contains all the information about the image we have just created.

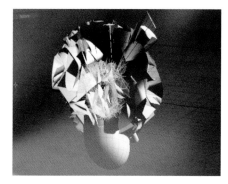

8. *Outputting.* The final print is outputted using a rapid-format prototype printer. The finished image, flowers in a vase.

The sketchbook

Nothing has changed more for artists in recent decades than how they can record ideas.

Left: We use the keyboard and mouse as readily as sketchbooks for recording ideas.

Below right: Sketchbooks are both intimate and practical. They never crash and have an indefeatable power source.

Below left: *Bound for the Spitway*, David Parry, etching, aquatint and *a la poupee*, 30 × 21 cm (12 × 8 in.).

The sketchbook is the artist's most intimate resource, the place that we keep the myriad notes, sketches, swatches, marks, words, comments, colours, observations, scribbles, clippings, scraps, found bits, lost bits, stuck bits, torn bits, places, people, names, postcards, newspaper gleanings, empty sugar packs, biscotti wrappers, tin labels, packaging, tickets, receipts, shopping lists, Post-it® notes, dead leaves, dried flowers, smudges of grease, dabs of ink, watercolour studies, charcoal, pastel, pencil, pen, biro, crayon, chalk, shoe polish, mud, grit, sand... the list is never-ending. Anything that stimulates us, we need to capture it in some way to remember the idea of it.

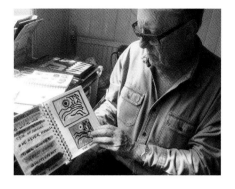

The sketchbook is the artist's most intimate resource. Artist John Hoyland shows the author his sketchbooks.

Cut out shapes help to resolve composition.

Experiment with alternative ideas.

You can find inspiration anywhere.

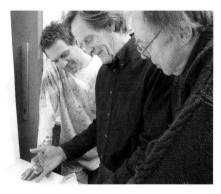

A sketchbook is worth a thousand words.

Since the advent of photography artists have collected photographs and photographic imagery to use as artwork or reference material. In some ways, the photograph has become equal to the sketchbook in recording information that we need to make our own images. The photograph as a reference source can have an emotive value as relevant as that of a sketch or drawing.

Digital cameras now allow us to output images directly from the digital camera into the computer, which has become yet another container for reference material. Photographs can be also scanned directly into the computer via a scanner. Pages of your sketchbook can be scanned directly into your computer. Moreover, the software programs that we use on the computer start as blank pages, empty documents in which we record ideas and create images. So the computer has become another type of sketchbook.

Some artists now use the computer screen in the same way they use sketchbooks – to record new ideas and work out how to resolve old ones. Folders are labelled, dated and stored on the computer with the relevant jpegs (image files) and documentation for ideas, and are as readily available for use as the sketchbook we open to make a drawing or quick sketch.

Somerset Soft White, available as textured and satin, 300 gsm, 56 cm × 76 cm is an excellent professional quality cotton printmaking paper.

The scanner, printer, computer and digital camera are used in many photographic printmaking processes.

Making an image using woodcut and Corel Painter IX

Using the computer as a sketchbook encourages you to think differently about the image and to use the materials available to render the image differently. The digitally created image in the following sequence is printed out onto Lazertran film as an inkjet print. The artist sees that outputted image as a print, but the print itself is destroyed when it is melted onto the surface of the wood with turpentine. The image is there as a template to guide the artist when cutting the wood's surface. The digital element of the image is destroyed in the process of putting it onto the wood, and thereafter the making of the image is about the process of woodcut. Thus two different printmaking techniques were combined to achieve the final printed image that the artist wanted.

Images imported into computers are altered digitally with specifically designed software programmes.

The artist, Jason Oliver, says, 'I use the computer as a sketchbook. I primarily have, for the last four years. I literally have thousands of images on CDs. These CDs are sketchbooks. Even the 3D space that we created in the previous sequence using the Modo program is a sketchbook page to me'.

The following is a sequence showing the changes that the software program Corel Painter IX can bring to bear on a sample image. The tools of the program literally recreate the texture of a woodcut for the imported image, which in this case was a photograph. The image used for this demonstration is titled *Pipe* (2008), by Jason Oliver.

1. Start with a photo. Duplicate it.

2. Duplicate it as a tracing. This makes the image invisible.

3. From the equipment menu choose the tool you want to make the printed image.

4. For the demonstration the Painting tool was chosen.

5. The image appears as the Painting tool is used.

6. Note the broad brush-like strokes being made.

7. Choosing the surface detail.

8. The image is given the appearance of a woodcut.

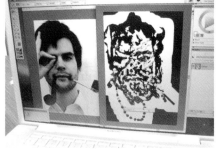

9. The image is finished. This will be used to make a woodcut.

10. Print out the image as a Lazertran print. Lazertran is an acetate film that can be melted onto the surface of the wood with turpentine.

11. The Lazertran image is placed on the woodblock.

12. The image can be cut into the surface of the wood just like a normal woodcut.

PROFESSIONAL COMMERCIAL PRINTERS

Often a professional commercial printer is crucial to the artist in the making of photographic positives. Finding a commercial printer that you can work with and trust is invaluable.

Commercial printers and graphic-imaging suppliers provide excellent resources for the artist-printmaker – technologies, services and facilities. I visited the graphic suppliers we use at Artichoke Print Studio, MG Visuals Solutions on the Old Kent Road in London, to ask them about commercial printing and how they see it in relation to fine art. The following are my questions and the answers of head designer Steve at MG Visuals.

Megan: You are a media/graphic-design company producing repro for screen-printers and designers who design for screenprint. Does this description adequately reflect your actual client base? Is an artist working in fine art an unusual client?

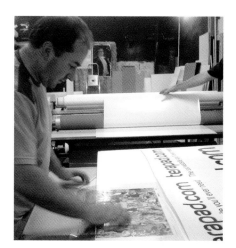

Steve: We are doing more and more inkjet, as screenprint will stop. There's not that many like you (Artichoke) – probably only 6% of our clients want to use inkjet creatively. Costs are the same across the board for everyone.

Megan: How would you describe the products that result from the technologies/services/facilities? As art? Artwork? Fine art? Commercially, is there a difference in the description for the images you produce?

Steve at MG Visuals checking the stochastic for the photo-etch image *Have a Nice Day, Mr Blake.*

Steve: We don't see them as artwork – they are tools for printers. They are media. If something happens to them, we wouldn't be heartbroken, like an artist would or might be.

Megan: In layman's terms, what service do you provide for an artist-printmaker?

Steve: From the point of view of

Design prep at MG Visuals Solutions Ltd, 674 Old Kent Road, London SE15 1JF.

artwork, we can scan it to put it into digital format. We can retouch an image while maintaining the integrity of the original. We dust for imperfections, do general cleaning and conservation. We don't change artwork. We then save the image file in a format that the imagesetter understands – for example, EPS. Then we convert the image to RIPS, which means converting the artwork to dots. The imagesetter is a laser which projects light at the film to expose it. The processor develops the film. The end result is a sheet of film with nice dense blacks.

Megan: What is your definition of digital technology?

Steve: Anything that has been through a computer at some point. Pretty much everything these days! Anything that involves a computer. Any film work from the last twenty years. Before we used imagesetters, it was camera work, exposing and masking.

Megan: Fundamentally, what is the difference between the camera and the imagesetter?

Steve: The imagesetter takes information and converts it into pulses of laser which pass onto film, which in turn creates an exposed area on the film. The camera works through a system of lenses and exposes the film as it sees it.

Megan: Is one better at capturing image information than the other?

Steve: In theory the camera. It is inherently dependent on light and its optics are purer. The laser only travels near the film. Whether or not you can see the difference, it is there. The grain of film is finer than the resolution of the laser. Film picks up more information than a laser can project.

Megan: What does the word 'print' mean to you?

Steve: To transfer an image into media, a substrate, to use the most basic term.

Megan: How did you become an imagesetter?

Steve: I studied graphic design and technical drawing at college. Eight years in a graphic-design studio doing paste-up with drawing boards. Computers replaced all that.

Megan: What did you think of computers?

Steve: Great idea. We bought one to share. I did a one-day course – turn it

on/print out text. As each job came in, we learned as we went along.

Megan: Explain what a computer does to an image.

Steve: The computer interpolates or regenerates. But the original pixel content has to be there – the quality of the original source material is important. The more image information the better. Imagine 1 million pixels per inch in correlation to the resolution. No printer does that yet, but a scanner now does. You used to use an analogue proof to produce an image of CMYK. Digital is high-resolution inkjet that is calibrated to the films you produce using pixels per inch. High-end quality would be 9MB or more. That is what you need if you are working on images that are 240 x 120 cm (8 x 4 ft) or larger – 2 to 3 MB is suitable for an A3 size print. But it is in the resolution of the initial image that the quality of information in the image is created.

Megan: What are printing inks?

Steve: Printing inks are pigment. Inkjets are finer inks for inkjet machines – ink pigments used to be water-soluble, but they are now all permanent. Polymer-based pigments such as UV inks, dye-based inks and solvent-based inks (the last of which are used for outdoor vinyl displays) are now the industry norm.

Megan: What is the way forward digitally for a business such as yours?

Steve: Unfortunately film is dying off. There are fewer and fewer suppliers. Eventually, artists won't be able to afford the equipment. Everything is going to screen – from computer to laser to screen. Companies will be able to do any size as in-house – they will be able to do away with film altogether. So a company like ourselves who provide images based on film output need to compete to survive – so more inkjet. Things become superseded so quickly now. You can still use it, but you try and choose things that don't go out of date quickly.

Untitled, Alex Gough, 2006. Photo-etching and aquatint, 39.5 x 29.5 cm (15.5 x 11.5 in.), University of the Arts London. Printed at Artichoke Print Studio.

MOMENT OF TRANSFER

One of the most wonderful and crucial elements of printmaking is the moment of transfer.

This point of issue – moment of transfer – is vital and without it the process of making a print does not actually happen. Transferring an image INTO another media often sends a ripple of worry, confusion and misunderstanding into the minds of many; and too often initiates the printmaker's dilemma of what is a print and what is not.

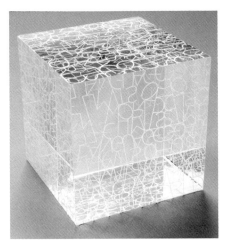 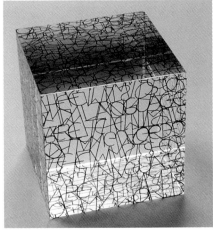

Above, left: *Wittgenstein's Dilemma,* Tom Phillips RA, CBE, 1999. Silkscreen on acrylic cube, white letters, edition 25, 15 cm (6 in.) cubed.

Above, right: *Wittgenstein's Dilemma,* Tom Phillips RA, CBE, 1999. Silkscreen on acrylic cube, black letters, edition 20, 15 cm (6 in.) cubed.

Below: Digital series, *Wittgenstein's Dilemma,* Tom Phillips RA, CBE, 1999. Silkscreen on acrylic cube, white letters, edition 20, 15 cm (6 in.) cubed.

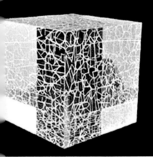 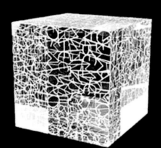 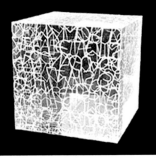

This confusion extends to people who buy prints, run galleries, even collect prints, as well as, we ourselves, the printmakers who make prints. Printmaking is a fantastic art form that supports traditional techniques and cultivates new technology. It is the most wonderful medium to use for original expression.

The words print, photo, photographically, photocopy, digital, inkjet, giclee' all create the most diverse reactions in the world of printmaking amongst artist printmakers, painters, sculptors, teachers, students, galleries, archivists, conservationists, collectors; everyone who has ever involved themselves in making a print, buying a print or come in contact with print for some reason at some stage. The word print mystifies all of us. That is its most powerful attribute.

Printmaking's fantastic ability to absorb and adapt tools in which to create and transfer images is its strength.

I think sometimes it is forgotten that the crux of making a print on a substrate/matrix is that it is then transferred onto another type of media (e.g. paper…card, canvas, acrylic resins, cloth, ceramics, metal, glass, etc.). The necessity to transfer the information we have about the image we have conjured in our minds is crucial to making that image real.

The acid attacking the selected areas of an etching plate is as vital to making that image occur as it is for the paint on the paintbrush to make a mark on a canvas.

Where's the real one?

Recently, I was teaching a group of young students. They were all from eight to nine years of age. In the printmaking project we were doing they had been making relief prints. We sat down to talk about making prints. (The kid's answers are all shouted with enthusiasm.)

Megan: You made relief prints today.
Kids: Lots of cheering.
Megan: How many did you make? More than one?
Kids: Yes!
Megan: So what is the second print that you made today?
Kids: Another print!

Making a picture into an etching, or a lithograph or a linocut, is a deliberate decision taken by the artist.

Megan: It looked the same as your first one? Does that mean when you make more than one they are copies of each other?
Kids: No!
Megan: Why?
Kids: Because they are real!
(Right then and there, in that moment, they had made my day!)
Megan: Correct! What does real mean?
Kids: Original!
Megan: And what is the name of the exhibition we came to see today?
Kids: Originals!

I don't know why that interchange made me happy. I think it was because they were so positive and absolutely certain about what we had been doing. We had come to an exhibition at the Mall Galleries, London, called *Originals Contemporary Printmaking Exhibition* to looks at prints and to make prints. They saw clearly that what they had made were real pictures and all of those pictures were real original prints.

Keeping it real

Making a picture into an etching, or a lithograph or a linocut, or a drawing or a watercolour is a deliberate decision taken by the artist. For the printmaker to be able to work freely with an idea the issue of transferring it is ever present. The printmaker is constantly juggling two positions of making. Making the image on the plate and making the subsequent images that the permanent image on the plate allows the printmaker to then create. Hand-making and printing a plate is time consuming and difficult. It is not like pressing a button on a photocopier.

The printmaker is involved in choosing how his image will be made from the very beginning. And in the beginning more often than not is the sketch.

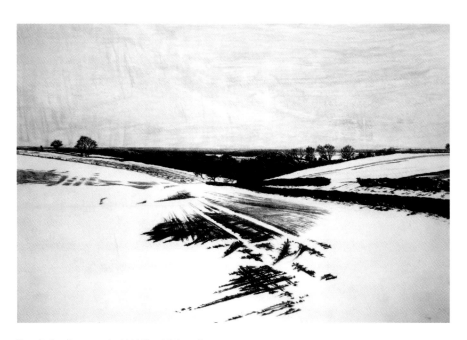

Sketch for *Snow on the Wold* by Melvyn Petterson.

Many artists record and work out ideas in sketchbooks. These working ideas can be anything from notes, scribbles and colour swatches, to fully formed drawings/painted studies. The blank matrix – the copper, zinc, steel, card, computer screen is then prepared for the idea. The moment of transfer has been initiated.

Ghost, Morgan Doyle, 2007. Open-bite etching, 26 × 26 cm (10 × 10 in.).

The idea already exists as a sketch, doodle, scribble, wash drawing or charcoal mark and is going to be translated into another media. As printmakers we take this step quite easily.

Transferring the image happens again and again in the printmaking processes the printmaker chooses to use. This necessity to transfer the information that is needed to inform the image is what keeps it real and guarantees that the versatility and invention within printmaking media will continue to flourish and prosper.

I have taken the time to describe the moment of transfer because it is an important aspect in why we choose the tools and materials we have available to ourselves as printmakers to use to make a print.

The idea of transferring an image is too often seen as a negative aspect of making a print because the artist must be reproducing it or copying it, so it can no longer be original. The printmaker who uses hands-on creative endeavour to make a printed image will always make an original print.

Suduko, Tom Phillips, 2006. Five photo etching plates, aquatint and nine colours *a la poupee*. 27 × 27 cm (10.5 × 10.5 in.).

STEREOSCOPIC AND LENTICULAR PRINTS

The stereoscopic print and the lenticular print are fascinating and unusual combination prints. Seemingly contemporary merely because of their exotic names, they are both combination prints that are not that widely used by printmakers. Each involves creating the illusion of depth within a 2-dimensional print.

Stereoscopic prints

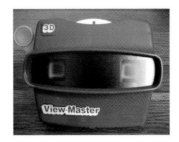

Seeing images 3D involves looking at a pair of images placed side by side in a stereoscope, a viewing method invented by Charles Wheatstone in 1838. You may remember the View-Master viewer from when you were young, or 3D glasses with one red lens and one green lens. These give a rough approximation of seeing in 3D.

It's our View-Master. My sister still has it! Image courtesy of Tricia Sears, Portland, Oregon, USA.

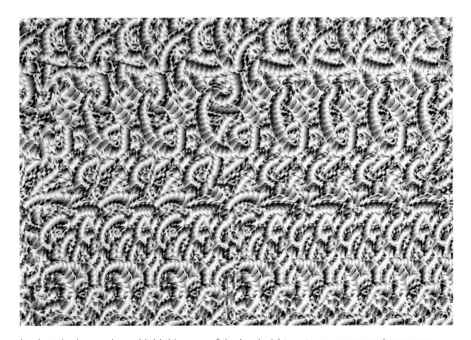

Look at the image above. Hold this page of the book right up to your nose and very, very slowly pull it away from your face. Look through the image without focusing on it. Try not to blink, and a hidden image will magically appear. (*The answer is at the bottom of the next page*).

2D images are also made stereoscopically. These are rare as artwork and even more rare as prints. Most often such images are created for fun.

In theory you are looking at this image stereoscopically – two images arranged together to create another. An object such as a sculpture or a book has a physical weight (actual bulk) and volume (a space that is filled with wax, wood, bronze, etc.). To create the illusion of depth in a 2D picture plane the printmaker must resort to visual tricks to create the illusion of going into, through and around the image.

Lenticular prints

With stereoscopic and lenticular printmaking techniques you are literally animating the image you are working with. The lenticular viewing position is more closely related to animation – the image is flipped or sequenced in strips. Lenticular printing was invented in the 1940s as a commercial printing process for advertising graphics. Advances in photographic printing processes and commercial lithographic printing equipment such as presses and lenses have led to lenticular media being more widely accessible to artists to use creatively.

Crackerjacks!

I remember lenticular images mostly as toys, particularly in a childhood treat we had called Crackerjacks. The prize inside the box was nearly always a lenticular gizmo – an image that jumped or changed direction.

The following is a simplified explanation of lenticulars, which, because of the nature of the processes needed to make them, are combination prints.

There are four types of combined lenticular prints:

1. Transforming print: An image that appears to transform into another.
2. Motion-capturing print (animated): An image that appears to be in motion.
3. 3D print: An image's viewing angle changes slightly when viewed from a different vantage point.
4. Zoom print: The image gets bigger or smaller.

A typical example of a commercially made lenticular image. Lenticular images are more often than not made as postcards.

Answer: The hidden image is of Easter Island statues.

A commercially made lenticular image of wild mustangs. The postcard is from my niece and nephew, Grace and Peter Papadopoulos. Thank you!

HOW TO MAKE A LENTICULAR PRINT

Most printmaking studios and workshops do not have the equipment *in situ* needed to produce a lenticular image. For someone whose interest lies in this direction, a specialised commercial printer is needed.

Making a lenticular image is a multi-stepped process that involves combining a sequence of the sliced image with a lenticular lens. The choice of how many images you use is dependent on the combined lenticular print you want to make. The minimum amount of images you need to create a lenticular print is two.

Modern day miracles, Bea Denton, as digital lenticular, 2007.

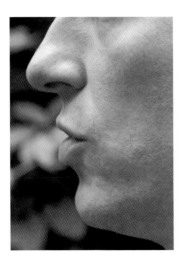
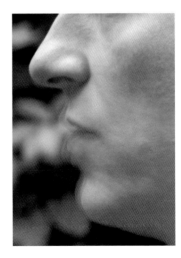

To make a lenticular image you will need:

1. A computer and scanner
2. Image-making software (Adobe Photshop® or Illustrator®)
3. Interlacing software (an image-splitting computer program)
4. A substrate (usually paper/card of a synthetic nature)
5. A lenticular lens screen.

A lenticular image is comprised of two elements – a printed image and a lenticular lens.

The lenticular lens is the screen through which you view the printed imaged. Combining two images will create an image that alternates in one direction and then another as you look at it, simply by changing your viewing position.

The most important element at this stage is your artwork. Using Photoshop® or Illustrator® is the easiest way to create your images. This allows you to make not only stationary images on a basic background, but also to create different stages of this image to use as multiple frames for a more complicated lenticular print such as a motion-capture or animated image.

Artwork

Using Adobe Photoshop® as an example, save your artwork in layers. Photoshop® is an excellent software program for this exercise. All the files you create should be in CMYK. Working with two images will give you a satisfactory and extremely effective changing lenticular image. But you can also experiment with more images and layers to create more complicated viewing changes.

Lenticular images are best made using a commercial printer that can lithoprint directly onto a lenticular lens screen. Once you have created your

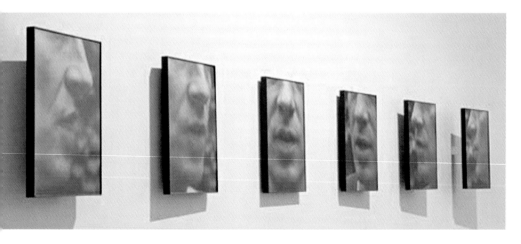

Modern-day Miracles, Bea Denton, 2007. Seven A3 size lenticular images, sound installation and book.

artwork, you will need to save all your image information on a CD and take it to a commercial printer who specialises in outputting images onto lenticular lenses. Lenticular lens substrates are not readily available, nor are they inexpensive. Having a commercial printer with the proper lithoprinting equipment output the final image is not only a more hassle-free way of making your lenticular image, it also ensures that you get the desired effect in the most cost-effective way possible.

What a commercial printer will do with your artwork
There are three basic steps that will happen:
1. Making a flip
2. Interlacing the image
3. Outputting the image onto a substrate.

Step 1: The flip
A lenticular image is a picture in which one image is viewed after another. The angle of your view changes the nature of the image. A very early way of making an animated image move was the flipbook, involving a series of changing images on successive right-hand pages of a book, which give the appearance of

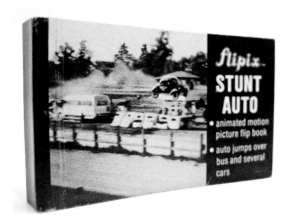

This sequence of the pages of a flipbook turning helps illustrate what the movement in a lenticular image is based on.

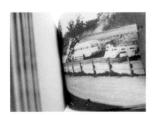

Animated motion-picture flipbook sequence image.

Sedan car jumps over bus and cars.

The final image in the jump sequence.

a moving image – for example, a person running, cats fighting, a car speeding – as you flip quickly through the pages of the book. This is the origin of the use of the word 'flip' in describing the core image being captured in a lenticular display.

In a lenticular image, the flips consist of strips of the image. The width of the strips creates the angle of viewing when the strips are interlaced from one side of the image to the other. You can use as many flips as you want in making your lenticular image, as long as they are all the same size. Of course, the more flips you use the more preparation is needed to construct the sequence of flips.

Step 2: Interlacing

Interlacing software is what you use to take the images and cut them into very narrow strips. The best way to understand what is happening when the strips of the images are interlaced is to imagine you are shuffling a deck of cards.

Spilt the deck in half. Slowly release the first card from the half of the deck in one hand and do the same with the first card from the half of the deck in the other hand. Then do the same with the next two top cards, then the next, and so on, until all the cards are interlaced which each other.

This is what happens when the strips of each flip are interlaced. In a lenticular print made with two images, the first strip is from image one, the second strip is from image two, the third strip is from image one, the fourth strip is from image two, and so on. The software program then saves the interlaced image as a single file, which can now be printed.

Step 3: Outputting the image onto a substrate

This interlaced image can be outputted using any high-quality printer on a suitable substrate. The substrate can be any paper or card, but one of a substantially resilient synthetic quality is best for the purposes of handling and attaching it to the lenticular lens screen.

A lenticular lens screen is a sheet of plastic the surface of which to the naked eye appears to have rows and rows of ridges. These ridges are cylindrical in shape, and each cylinder shape is the actual lens. These lenses are called lenticules. The focal length of each lenticule is equal to the thickness of the transparent plastic sheet on which they are adhered. Each separate lenticule magnifies a single strip of the image underneath when the sheet is placed on top of the interlaced image. Because the lenticules are cylindrical, when you change your angle of view the image also seems to alter.

HOW TOOLS AND TECHNIQUES COMBINE AND EVOLVE

■ Among the variety of tools available to the printmaking artist, many are specific to a particular printmaking technique. Some tools have been gradually adapted as the process for which they were originally designed has evolved. Using trusted traditional tools alongside new tools and techniques often provides the printmaker with the most satisfying creative combinations.

The tools used are specific to each printmaking technique. Among the various printmaking tools available to the printmaking artist, there are some that combine more than one function.

Combining the scraper tool with the burnisher tool gives us the scraper-burnisher. Other possible combinations are the drypoint-burnisher and the drypoint-scraper.

Situation, availability of suitable materials and equipment and ingenuity all help stimulate invention and determine how a tool might be used. Sometimes a new technique arises because we don't know how a tool should be used, but we try using it anyway! The incorrect use of a tool often provides us with the mark we desire.

 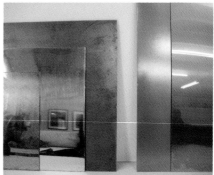

Many tools and pieces of equipment are used in combination printmaking. Sometimes the tools evolve into newer versions of established themes, such as the evolution of lithography: from the lithographic stone, to aluminum/zinc litho plates, to the photo litho plate (picture on the left). In the right hand picture, copper, zinc and steel, time honoured matrixes are crucial in the use of photo emulsions which are applied to their surface via films or roll-on emulsions or come ready combined such as the solar flexo plate. Note: that in every case the older technique has not been superseded, just added to by the new one.

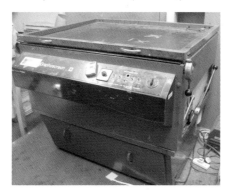

The UV exposure unit at Artichoke Print Studio. It's big and it's heavy (we've moved it more than once), and for photographic processes it's an indispensable tool in a printmaking studio. Without it, many of the hybrid combinations used by printmakers would be impossible to achieve.

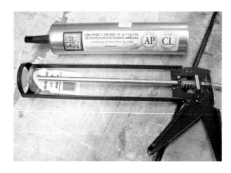

Sometimes a crossover element used for another purpose, such as the caulking gun, makes life just that little bit easier, as is the case with this ink cartridge.

And some things never need to change – the lino bench.

Left: Your tools are your friends, no matter how incorrectly you use them. An awareness of what a tool and the alternative marks it offers is a bonus to the way an artist creates.

Above: Even the humblest of objects can become a powerful creative element in the artist's toolkit.

The positive as a tool in printmaking combinations

The positive

Positives are transparent substrates that have an opaque image on them. Light-sensitive photographic processes in printmaking are dependent on them.

An example of a photo image with a halftone-screen covering.

Types of positives

Photocopies (oiled paper or acetates), autographic drawings on drafting film or tracing paper, photographic, digital or contact screens (stochastic, litho film, Photoshop® outputs onto clear acetate, four-colour separations and halftone screens).

The halftone screen and the random-dot screen (dithering)

Both the halftone screen and the random-dot screen are used to establish a printable tonal gradient in the image if it is not already sufficiently present. Graininess and contrast is crucial to the image. A pale drawing will not expose successfully (see Digital Printmaking chapter, page 17, for further details).

The halftone screen has been around for a long time. In the 1890s the first halftone screens were used for informing the structure of the tones that made up a continuous-tone photograph. The information in the image was broken down into a series of dots.

Two glass plates with a series of lines closely laid together on the surfaces were inked with a dark pigment and then placed together so that the lines crossed each other at right angles. When the film, combined with the negative of the image, was exposed to light, the intersecting grid of lines acted as hundreds of lenses, breaking the image up into hundreds of dots. Where the image was darkest there were more dots – black and large and close together; where the image was lightest there were fewer dots – small, still black, but infrequently dispersed in the image area. The fineness and closeness of the lines on the two glass plates determined the fineness of the tonality of the image.

This was the earliest form of the halftone system and it is still the underlying principle in how the halftone is used today.

The halftone provides a variety of dot structures to use in the image. The random-dot screen adds an aquatint effect. Other dot configurations include cross-line, straight-line, wavy-line and mezzotint. The random-dot screen is a popular screen among artists for use in photographic work – the answer lies in the word 'random'. It is the least mechanical format of all the dot-screen patterns.

Traditional tools and power tools

It takes years for a printmaker to acquire the tools they use to make prints. These are incredibly personal to each artist, chosen for the autographic mark that most satisfies or stimulates them. After years of use, you know your tools intimately. You can even tell when someone else has used them, because a different wear and tear is created on the tips of nibs and points or the angle of a scraper blade according to the way different artists hold and use their tools.

Combining the use of power tools and traditional printmaking tools offers the printmaker some of the most exhilarating and energetic means of making an image on a printing substrate. Not only can the printing plate be scratched and scored, buffed and polished, but large areas can be dealt with quickly and vigorously, yet still achieve delicate and subtle surface tones and marks.

Drypoint and power-tool prints

Drypoint is the most autographic of all the intaglio techniques. The hand, in combination with the chosen mark-making tools, is the sole driving force behind how the image takes shape on the plate. The greater your range of tools, the greater the range of marks you can make on the surface of your plate.

The scratches and marks you make create the character and the atmosphere in the image on the plate. Drypoint therefore demands a sympathetic rapport with the plate surface, as well as a careful approach. You are moving metal around in a creative tangle of burrs and grooves, both shallow and deep, with wisp-like threads of metal or shards coarse enough to tear your skin if it catches the edges of the torn metal that your tools have thrown up. This is what makes a drypoint image so rewarding – the image itself seems alive on the plate before it is ever inked and printed.

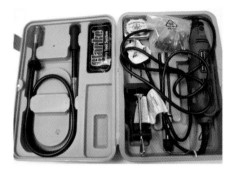

Power tools such as the Dremel™ (and other brand names) are ideal for use at home or in the printmaking studio. They have tips suitable for use on zinc, copper, steel and aluminium.

Above: Power tools such as the Dremel™ (and other brand names) are ideal for use at home or in the printmaking studio. They have tips suitable for use on zinc, copper, steel and aluminium.

Left: A copper etching plate which has been cut to shape using a jigsaw.

Sanders not only polish the surface of metal plates, but can also scar and bruise the surface to create fluid tonal areas of different scales and depths. The best way to find out if using power tools is a way you may want to make an image on a plate is to experiment.

The artist-printmaker Melvyn Petterson RE, NEAC, who is one of the directors of Artichoke Print Studio, did exactly that in making this large-scale drypoint on aluminium using both traditional drypoint tools and power tools. The following picture sequence records the plate being made.

Power-tool drypoint print: picture series

1. Work in progress on the surface of an aluminium plate.

2. The power tool in use on the surface of an aluminium plate.

3. A power-tool tip.

4. A power-tool tip that gives an effect similar to sandpaper.

5. Sandpaper being used on the plate surface.

6. Detail of sandpaper marks on the plate.

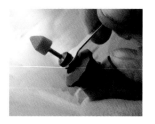

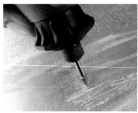

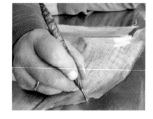

7. Changing the tool tip.

8. A new power-tool tip.

9. Using a drypoint needle.

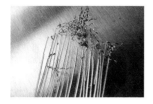

10. Drypoint burr on the plate.

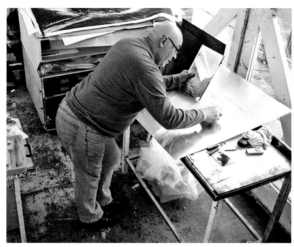

11. Note the raised, torn metal that has been pulled up. This catches and holds ink.

12. Studio view of the artist at work.

13. Sharpening the drypoint needle. Keeping tools in good nick is essential to their longevity and the quality of the marks that can be obtained from them.

14. A mirror is a useful way to reverse the image when you are working from photographs or drawings in sketchbooks.

15. The roulette.

16. The motion of the roulette when quick and firm can cover large areas of the plate in tone.

17. The scorper.

18. Using the scraper on previous marks that have been made.

HOW TOOLS AND TECHNIQUES COMBINE AND EVOLVE

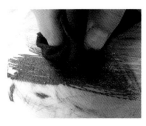

19. Plate texture detail.

20. Plate texture detail.

21. Inking a selected area of the plate with black etching ink to see how the textures on the plate are developing. (The artist used a mixture of Graphic Chemical F66 and Intaglio Shop Black. See suppliers list.)

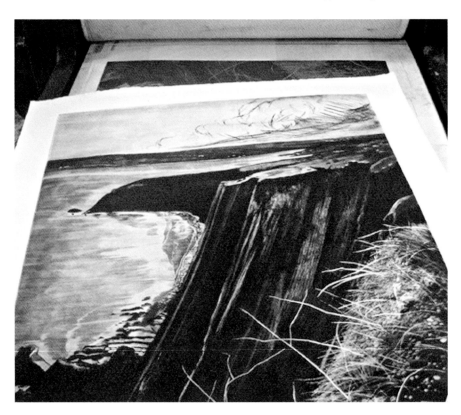

22. The Power Print! The plate has been inked in its entirety and a proof taken of the image. It's fantastic. Picture sequence and drypoint plate and image courtesy of Melvyn Petterson, Artichoke Print Studio.

COLLAGRAPH

The collagraph print is probably the one individual printmaking technique that can be said to be a pure combination print in itself. It combines the aspects of relief print and intaglio print in the making of the collagraph plate and in the printing of the plate to create the final image. Moreover, there is a third printing technique the collagraph plate allows – the rich, raw textures built up and scribed into the collagraph surface make superb embossed prints.

It is also a continually surprising printmaking technique. Literally any surface or object that you can imagine or conjure up, there is a way that you can take a print from it.

Though it seems a fairly modern printmaking technique, there is evidence that artists were applying adhesives to copperplates as early as the nineteenth century. An example of an early collagraph print made in 1893 is in the University of Georgia Museum of Art.

Picasso, Braque, Schwitters and Gris all made assemblages and collages, which were incorporated into printmaking plates. In 1932, the German expressionist Rolf Nesch is officially acknowledged to have made the first collagraph plate as we understand that term today.

Two simple elements create a formidable printmaking medium.

'Colla' means glue and 'graph' means drawing. You glue your drawing to a chosen substrate or base

It's cardboard! And glue.

layer. However, the simplicity of the ingredients in no way means that we have a lightweight, unimportant printmaking tool. In recent years, some of the most subtle and beautiful images in printmaking have been made using this method.

When all materials needed in the collagraph design have been glued to the base surface, seal it with a sealant such as shellac or varnish, then ink and print. If it is printed without being inked, this is called a blind emboss.

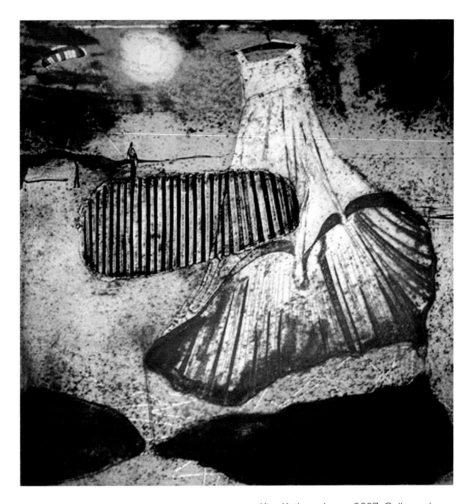

Kite, Kathryn Jones, 2007. Collagraph. 56 × 76 cm (22 × 30 in.).

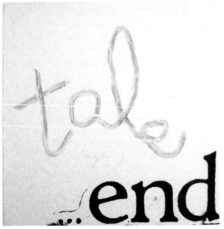

Tale End (book plate), Megan Fishpool, 1993. Photocopy transfer litho with lead emboss, 40 × 40 cm (16 × 16 in.).

The base layer of the collagraph

The base layer the collagraph is built on can be any type of thin card (mounting board, greyboard, corrugated cardboard, Everest board or an old cereal packet will do) thin Perspex or acrylic, metal (zinc, steel, copper or aluminium) or even photolitho plates will serve as suitable bases to which you can attach all kinds of textures.

A well-made collagraph will last indefinitely. If a mishap should occur – for instance, a crack or a particular element tears away – the plate can be mended, lightly relacquered and used again.

The collagraph plate and image has a unique attribute, one that most other printing matrixes don't share, in that they both improve with age and use. This is because after the first few times the plate is inked and passed through the press during proofing its textures settle and take on a permanent and relaxed shape.

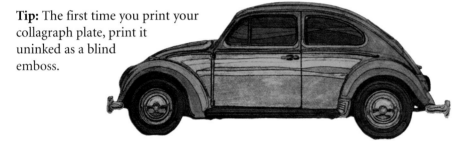

Tip: The first time you print your collagraph plate, print it uninked as a blind emboss.

Green VW, Barry Goodman, 2005. Collagraph, 36 × 36 cm (14 × 14 in.).

Dust the plate with talc to counteract the adverse effect of any lacquer that is not dry or that you cannot see, or any adhesive within a texture that is not visible to the naked eye, by rendering it non-tacky/-sticky in the event that it is squeezed out from under textures during the process of being passed through the press. The talc stops the paper sticking to the surface of the plate and creating a permanent sandwich of paper glued to the plate.

The resulting blind emboss is a fantastic print in itself, recording all the textural information of your image.

Notice the textural highs and lows on the surface of the collagraph plate.

A suitable plate thickness

The most important thing to remember about choosing your collagraph base is the thickness of the chosen substrate. Unless you are printing the plate by hand – for example, burnishing the surface – the card and the textures attached to it must be of a thickness that will go through a printing press.

The gap in most fixed-roller printing presses is approximately 2 mm (a little less than ⅛ in.). If, however, you have access to a sprung-roller press, where the roller can be adjusted to heights greater than 2 mm, you can create collagraph plates of greater thickness – on surfaces such as thin plywood or hardboard.

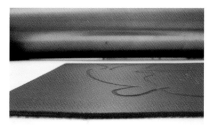

Top: Doorstep heights on the collagraph plate do not print successfully.

Centre: Large gaps and incompatible heights also do not print successfully.

Bottom: It is possible to adjust a spring roller press to adapt to different substrate thicknesses. This lino block is 4 mm (0.2 in.) thick.

Making the collagraph plate

The most important thing to remember in making the collagraph plate is to choose a suitable adhesive to bind the textures securely to the printing base. PVA and wood glue are the most suitable glues to use for collagraph. In my experience the best adhesive to use is UniBond™. Shellac may be used as an adhesive as well as a sealant. All spray mounts and rubber cements are entirely unsuitable for collagraph.

Inking up the collagraph plate is quite a vigorous activity, no matter how gently or carefully you apply ink to the surface and take it up again – with either scrim (tarlatan), soft rags, muslin or paper towels – the rubbing motion can rip, tear, crush or break off pieces of texture from the surface if they are not

In my experience of making collagraph, the best adhesive to use is UniBond.

properly attached with an adhesive of suitable bonding strength and compatibility with the chosen materials.

Materials to put on the surface of your collagraph plate can be whatever inspires you:

favourite fabrics, textile textures, wallpaper patterns, flocked, wood-chipped or embossed papers. Gesso (acrylic polymer latex), matte or gloss medium, modelling paste, texture paste and white glues also add a natural drawn quality to wet marks made on plates.

Textures

Tin foil, tissue paper, string, thread, twine, suitably dried leaves, grasses, ferns, pressed flowers, coffee grounds, tea leaves, carborundum (coarse, medium, fine), beach sand, garden grit, sandpapers, adhesive tapes.

With textures such as rice, grains, sequins, thick or soft plants, or objects that are too brittle or fragile, the most important thing to remember is to use common sense. In this regard, ask yourself the following questions:

• Will the textures withstand the battering they will get when inked?
• Will they be crushed in the etching press?
• Will they ooze all over the printing plate?
• Are they impervious to the adhesive you are using to attach them to the plate?

Chine Collé Paper
There are a myriad of textured papers – Khardi, Japanese, Korean and Indian papers – and innumerable sheets of stylised stationery. Intaglio Printmaker, Faulkiner's, Lawrence Ltd., John Purcell Paper, and R.K. Burt are only a few of the many suppliers of good-quality printmaking papers; Paperchase, Green and Stone, London Graphics Centre and Cornelissen are good alternative sources of novelty papers.

Natural textures such as dried leaves and feathers work well as collagraph materials.

Sandpaper, string and tarlatan are favourite collagraph materials for many artists (above three images).

• Are they too thick or sharp; hence, will they damage your printing blanket?
• Are they so dense that they will actually damage the roller of the printing press or the bed of the press? (For example, washers, coins, small gears, metal buttons and wire may be lovely, fascinating objects, but once attached to a collagraph plate they can give highly undesirable, unsuitable, even catastrophic printing results.)

The best way to incorporate these types of textures into your collagraph plate is to make impressions of them.

A coin embossed in a piece of card.

Printing blankets can be destroyed by collagraph plates with unsuitable textures that cut into the blanket, creating permanent marks which then offset onto the prints of other artists.

Printing the collagraph plate

Printing the collagraph plate is a bit like jumping into a swimming pool: it makes a much bigger splash than you might expect. The textures of a collagraph plate always hold more ink than you realise. The ink needs to be applied with care and really worked into the surface. This can be done with cotton buds, toothbrushes, scrim dollies and inking cards.

The two pictures show close-up detail of collagraph textures. The complicated folds and shapes created by these textures are what the artist spends most time on applying ink to.

Carborundum adhered to a plate with a suitable bonding adhesive makes effective and exciting textured areas.

An ink-rich collagraph plate results in a very satisfying print. Too much ink and the print will be smudged with the excess ink that has been squished out from covered ridges and trapped in the folds and layers that the gluing has left on the plate, resulting in a mess. Only by practising inking and pulling proofs from the collagraph plate can you become acquainted with how best to make the design on your collagraph plate print at its best.

An uninked sample collagraph texture plate. The same collagraph texture plate inked.

 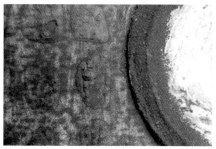

It takes a fair amount of time to ink a collagraph plate because of all the intricate textures.

Collagraph creates fantastic printing opportunities when combined with other printmaking techniques – etching, lithography, relief prints and screenprints. The raised surface of the collagraph contributes texture, embossing and fascinating overprinting marks to any of these other media. Combine them and enjoy the results.

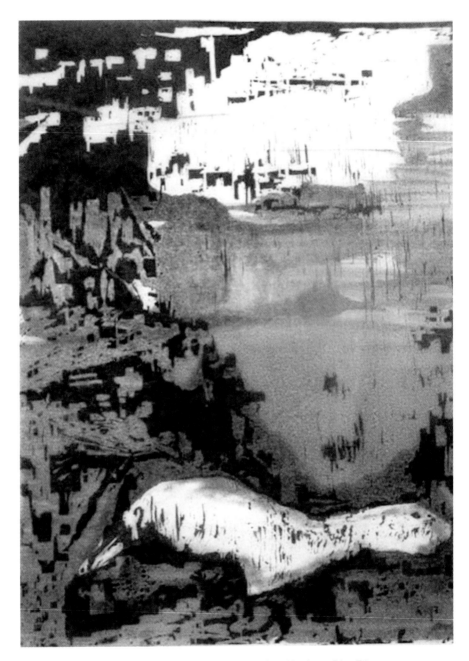

Reconfigured, Poppy Jones, 2007. Monoprint, linocut printed in three 56 × 76 cm (22 × 30 in.) sections.

MONOPRINTING COMBINATION PRINTS

The monoprint is a versatile and enduring favourite with almost every printmaker – a spontaneous and immediate way to render an image using colour or monochrome. It also combines successfully with absolutely every other printmaking technique.

The monoprint in its purest form is a single, unrepeatable image made in one go with an inky mark on an unmarked substrate. It is then lifted from that surface either by hand-burnishing or by running the substrate through a printing press.

A monoprint combined with another printmaking technique is still a monoprint; if more than one version is going to be printed, it is more practical to call the image one of a series of similar images. This is because, though the image from one of the other substrates is fixed,

An autographic mark.

the monoprinted substrate may vary quite significantly from one image to the next when it is combined with the fixed substrate. Hence, they are a series of monoprints, not an edition. Strictly speaking, using the term 'edition' is saying to the viewer that all the images are the same, or as near identical as possible.

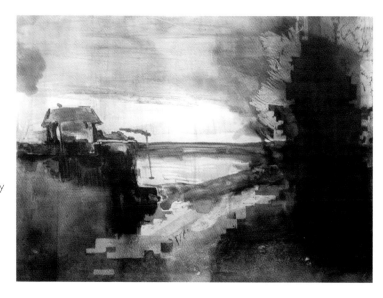

Lounge, Poppy Jones, 2007. Monoprint, digital woodcut, 56 × 76 cm (22 × 30 in.).

Tallis, Megan Fishpool, 2005. Etching with monoprint, 76 × 120 cm (30 × 47 in.).

Monotype and monoprint: is there a difference?

Historically, the term monotype is consistently referred to as the technique by which a single print is created by painting with inks onto a non-absorbent surface such as metal or glass. Monoprint as a term does not actually first appear until the late 1940s, when artists working in printmaking media evolved the monotype process by combining it with a variety of superimposed matrixes such as etched plates or lithographic layers. A new term was needed to describe the complicated mixture of procedures and monoprint was considered appropriate. Since the 1940s the two terms have become interchangeable in describing a unique printmaking image.

In more recent years, we discover that the meanings of the two terms are constantly flipped. Monotype in one instance means no mark-making interference with the substrate, while in the next it allows for repetition because marks have been made in the substrate. A monoprint can be taken from a substrate that has been marked and combined with a variety of printing elements to render the image differently each time the image is rendered. Whether monoprint or monotype, the process is refreshingly direct.

The monoprint image must be printed before the ink dries, which in the case of water-based inks is very quickly. Printing by press or by hand are the two main options, and you will get only one strong impression. There are no second chances. The design can be redrawn for a second impression but it will necessarily be different.

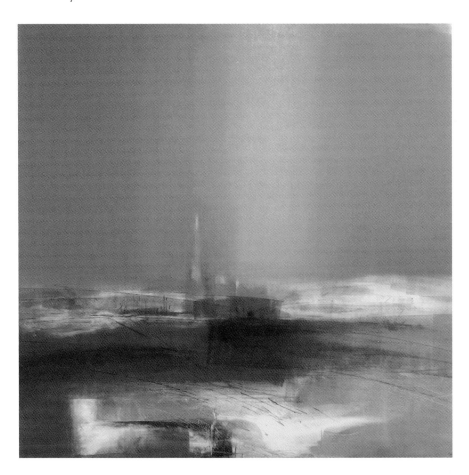

New World, Megan Fishpool, 2007. Monoprint, 105 × 105 cm (41 × 41 in.). The spontaneity and scope for personal expression that the monoprint offers makes it a stimulating medium to use for creating a complete and realised artwork.

Combination monoprints

The monoprint combined with other printmaking media provides endless permutations. In combination with another printmaking technique, a monoprint contributes unique 'what happens if I try this' moments to complement the planned intention behind the image.

Monoprint and etching

One of the most popular and dynamic printmaking duos is the monoprint combined with etching processes.

Depending on an artist's line of thinking about a particular piece, the monoprint can either be prepared beforehand or made at the same time as the etching plate. Is the etching made with the intention of fitting the monoprinted image, or is the monoprint made as a fully realised image with the etching plate working in combination to enhance the initial image and bring it to completion? The choice is yours.

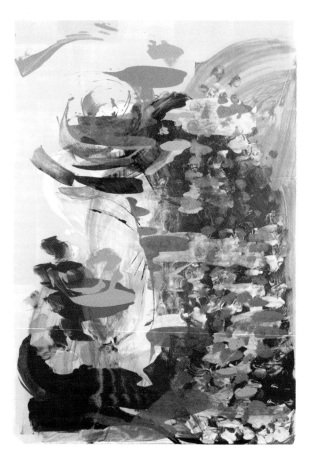

Untitled, Helen Clark, 2007.
Monoprint,
76 × 112 cm (30 × 44 in.).

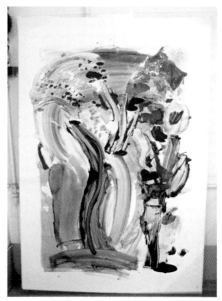

Above: True-Grain acetate with an image template drawn with a permanent marker on the non-printing side of the acetate.

Right: The monoprint has been in the water bath and is now self-blotting on the upright glass sheet. It will be further blotted using cotton blotters to remove excess moisture that is still present on the printing surface.

An image can be drawn onto a transparent substrate such as acetate or True-Grain (a textured polyester drawing film) with a permanent marker pen. This allows you to follow a template for applying the colours to your design. If this is combined with another process, the image can be drawn directly from the substrate it will be combined with so that it registers properly.

Place the monoprint you intend to print the etching onto into water in a paper bath, as you would do an ordinary unmarked sheet of printmaking paper. The paper used for the monoprint in this illustration is Somerset Double Imperial Soft White 300 gsm Textured, from John Purcell Paper. Ideally, the paper should be in the water of the paper bath for at least 15 minutes; other papers will need to be in water for different amounts of time, but for this particular brand, Somerset, 15 minutes is sufficient for your printing needs.

Prepare your etching plate. The image being shown in this chapter is a hard-ground etching made on a zinc plate. It was drawn freehand and then open-bitten in a nitric-acid solution of 10 parts water to 1 part nitric acid for 20 minutes. **Please see the Health and Safety chapter for how to use nitric acid safely.**

The bite on the surface of the plate is very chunky and raw. The larger lines of the image hold very little ink. It was deliberately decided that no aquatint would be used on the plate, so that certain lines would appear to have a grey centre tone from being bitten too wide.

Ink is carded onto the plate liberally with cut card squares (any old mount-board offcuts will do nicely for this purpose). Then the scrimming begins. The first ball of scrim is the dirty ball. The ink is worked into the lines with intent

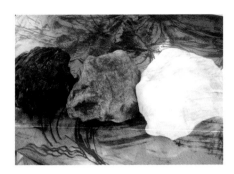

Dirty, medium and clean scrim balls used to wipe and clean the plate.

The plate surface being inked with etching ink.

and a firm circular motion. With this ball of scrim, you begin to remove the excess ink from the surface of the plate. The second ball of scrim is marginally cleaner, and is for evening out the ink on the surface of the plate – making sure that not too much is dragged from the lines, or left on the surface as ink scum or excessive plate tone. On a polished zinc surface, there will be very little plate tone, if any at all. The third scrim ball is for polishing the plate and for the final clean wipe. The edges are cleaned with a clean cotton cloth. Whiting is used on the edges if a pristine plate mark is desired.

Place the prepared etching plate on the bed of the printing press. Take the damp monoprint and blot the excess moisture from the surface. Cotton blotters or newsprint are ideal for this exercise.

Place the monoprint over the inked etching plate. Use tissue to protect the blankets from an ink mishap and to keep unnecessary moisture from the blanket surface. Paper contains size; this is absorbed by the blankets each time paper passes through the press in the printing process, thus causing the weave of the blankets to harden and become more pronounced with more and more use. Eventually, they need to be laundered to soften the weave and draw it tightly together again.

The monoprint and etching plate are run through the printing press together. Pull the blankets back and lift the monoprint gently from the etching. Printing inks can take a long time to dry, and a heavily inked monoprint may still be tacky. The pressure of

The inked etching plate on the bed of the etching press.

Untitled, Helen Clark, 2007. Monoprint with hard-ground etching, 76 × 112 cm (30 × 44 in.).

the roller will cause it to stick unnecessarily to the etching plate, and the surface of the paper may tear or shred if you pull the image away from the plate too quickly.

The combined monoprint and etching is revealed. The print is damp, so will need to be placed under drying boards and weights for several days.

Water-based monoprints

Water-based printing materials combined with oil-based printing inks is a combination many people are interested in achieving success with.

The interaction of the two combined media needs to be handled with care, as the oil-based printing inks can easily overwhelm the printing surface and make it impossible for the water-based crayons to make a true mark; instead they create tracks in the oil-based ink which print as white lines.

Water-based crayons and pencils used with damp printing paper create controlled and graphics-styled images. Shading and blending, tonal marks, crosshatching and line work are softened by the dampness of the printing paper, giving this particular way of making a monoprint a quality totally different from ordinary non-soluble crayon marks on dry paper.

It is to your advantage to use a quality water-based pencil or crayon – it will amaze you with its affinity with dampened paper and with the image it gives.

A selection of water-based crayons and pencils. Quality is paramount. Inexpensive crayons are heavily wax-based, and hence they are not pigment-rich. The key to successful water-based images is not to lather on the crayon marks too heavily.

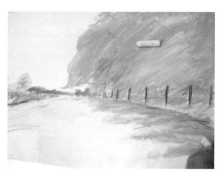

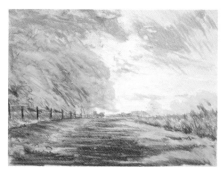

Water-based crayons being used to draw onto clear grained acetate called True-Grain.

The printing paper must be damp for the water-based image to transfer successfully onto the printing paper.

The finished print. The image on the True-Grain acetate still looks very intense, but all the water-based pigment has been removed by the pressure from the press. The residual pigment will not necessarily give another satisfactory print.

The rainbow roll, as demonstrated by Zeng at Artichoke, is a stunning way to use colour when mono-printing. Lithographic monoprinting (as pictured here), intaglio and relief monoprinting provide the artist with endless combinations from which an image develops.

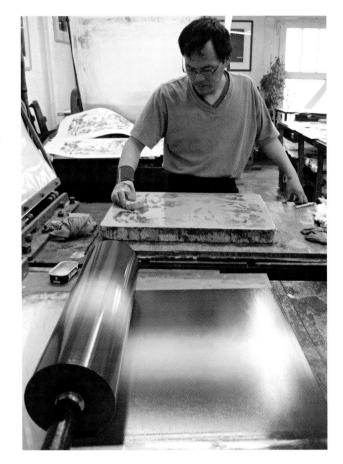

Offset monoprinting and photolitho

The lithographic offset printing press gives the printmaker the opportunity to work directly on the printing matrix on which the image is being made without having to consider creating the image back to front as a mirror image of itself; the offset press is designed to reverse the image for you.

A lithographic offset image is usually made using an image that has been created on a photolitho plate. Ordinary, grained and prepared zinc or aluminium plates can also be used. On traditionally grained aluminium plates the image is usually hand-drawn directly onto the plate, though photocopied images can also be successfully transferred using oil of wintergreen, acetone, lighter fluid or Windsor and Newton fixative spray to release the image from the photocopy paper. The offset press also offers the printmaker the combined duality of spontaneity and working with a right reading image.

The images in these pictures were created using photolitho plates and true grain monoprint elements.

Monoprint and photolitho

The following sequence uses a photolitho image combined with monoprinting.

The first colour of the image (black) was made by drawing onto drafting film using various opaque drawing blacks; lithographic crayons, india ink and acrylic paint.

The second colour of the image was made by blocking out large areas of another sheet of draughting film with Plumtree photo opaque. This is a ready-mix solution used for spotting out pinholes on photo positives. It is used for the making of photo screens and photo litho plates, and hybridizes itself instantly, by also being an excellent lift ground on traditional intaglio plates.

This picture shows the first plate printed as image with black lithographic ink.

This picture shows that yellow has been introduced into the image as a background colour. The overall colour has been printed over the black figures printed from the first photolitho plate. This two-colour image was printed as an edition of ten. The artist then took that edition and added monoprinted colour overlays to the image, making each print different. Hence, it can no longer be described as an edition. It becomes ten singular monoprints.

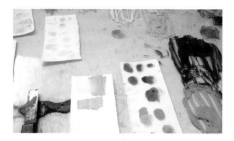

Most important is to have a palette of colours made beforehand, so that your thought process is not impeded and you can try out different combinations of colours immediately, or quickly make new ones from the ones you have already made. Then you do not lose the next mark-making idea.

Monoprinting has created a series of images which are unique combinations of offset monoprinting and photolitho. These pictures show two of the final combination prints.

An unmarked transparent printing matrix, such as True-Grain in this instance, is placed on the first half of the offset press bed. This is inked with the prepared monoprint colours and then offset onto the two-plate photolitho image. The alignment of the two printing matrixes, the True-Grain with the variable monoprint marks and the two-colour image, on the separate beds of the offset printing press make the addition of new layers of colour to the image easier. You clean the True-Grain and the roller each time you introduce a new mark into the image. This ensures the variable elements in each print.

These images were printed at Artichoke Printmaking Studio by the student who won the Artichoke Printmaking Prize at the Originals Contemporary Printmaking Exhibition at the Mall Galleries 2007. Images size 56 × 76 cm (22 × 30 in.).

LITHOGRAPHY: OIL AND WATER COMBINED

A short historical introduction

If anyone can be said to be a man of combinations it is Alois Senefelder (1771–1834). When you really want to make something you look at all the possible ways and permutations that exist and search for the best way to combine those elements to make the idea happen. In 1798, Senefelder needed to print text. His idea was to find a method that would allow him to etch writing quickly, thus allowing him to publish his plays and provide himself with an income. He experimented endlessly on copperplates to come up with a process that worked; and then he ran out of copper.

The ideal thickness for a litho stone to print successfully on a stone litho press is 5 × 6.5 cm (2 × 2½ in.). When variations in thickness occur, packing is used to keep the pressure even across the entire surface of the stone.

In the interests of economy, his experimenting led him to use the surface of stones rather than the surface of copperplates. In an attempt to cover up textual errors on the copperplates, he had made a poor substitute for covering varnish; this wasn't successful on copperplates, but it did have a curious effect on the surface of stone. We now know it as lithographic ink.

His knowledge of how ink is applied below the surface of an intaglio engraving and also how ink is applied across the surface of the raised image, or in his case lettering, of a wood engraving, gave Senefelder the inspiration to arrive at what he called lithography.

In his book *A Complete Course of Lithography,* published in 1819, he wrote, 'I was firmly convinced that I was not the inventor of the art of etching, or engraving on stone, or of taking impressions from stone: I even knew that etching on stone had been practised several centuries before me. But from the moment that I abandoned the principle of engraving, and directly applied my new invented ink to the stone, of which I am about to treat more amply, I could consider myself as the inventor of a new art and from that moment I relinquished all other methods, and devoted myself exclusively to this'.

Senefelder was a knowledgeable man; his stone of choice was a certain type of limestone available from limestone quarries in one particular valley in Bavaria, now part of southern Germany. This place is the only source of the stone he used, known as Solnhofen stone, which is also the only stone compatible with the process he devised.

A tusche drawing on a stone which has been gummed for storage until the next stage of the drawing is made.

Lithography is well-known as a commercial printing process. It was invented for that reason: Senefelder created 'the art' of lithography to accelerate the publication of his plays and increase his fortunes in the theatre. The introduction to Senefelder's book, *A Complete Course of Lithography* (1819), written by his publisher, R. Ackerman, is very clear: 'By the means of it, the Painter, the Sculptor, and the Architect, are enabled to hand down to posterity as many facsimiles of their original Sketches as they please. What a wide and beneficial field is here opened to the living artist, and to future generations! The Collector is enabled to multiply his originals, and the Amateur the fruits of his leisure hours'.

Lithography has another side. It is a medium that combines the freedom of drawing with the richness and elegance of a graphic line, and it took an artist of the genius of Francisco de

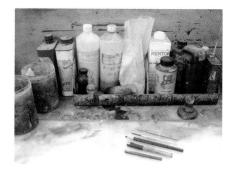

Lithography prep materials: resin, chalk, drawing tusche, gum arabic, neat's-foot oil, litho varnish, glass muller, pen and nib, litho-crayon pencil, snakestone.

Goya to liberate the true potential inherent in a lithographic stone. Goya's four images of bullfights, dating from 1825, completely altered the perception of what could be achieved with lithography. Lautrec, Bonnard, Degas, Picasso, Daumier and Delacroix have all followed since, enriching our visual sense with their use of the medium.

Hand lithography, as it is rightly described in fine-art printmaking, has taken many developments from the commercial world of lithography and combined them with the materials and techniques printmakers use for stone and plate processes in the studio. Even with the advent of photography, it has kept its supremely beautiful autographic printmaking form because of the direct contact with the stone and grained plate that the process demands.

Plate Lithography and Stone Lithography – both by Paul Croft, and published by A & C Black Publishers – are excellent books to read for in-depth information about everything that is possible with these two printmaking techniques.

Bus Ticket, Colin Gale RE, 1993. Stone lithography, 76 × 112 cm (30 × 44 in.).

Printing from the stone and the plate

Plate lithography developed very quickly after the initial use of stones. Zinc plates are the oldest form of plate lithography (known as zincography), while aluminium plates (algraphy), photolithographic plates and waterless lithographic plates have all been developed since. All these printing substrates can be combined with each other to create a printed image. However, it is when we see how effective the lithographic print is in combination with other printmaking processes that we realise just how versatile the processes of lithography are to use and how worthwhile it is to learn them.

LITHOGRAPHIC COMBINATION PRINTS

Intaglio and lithography

A lithograph combined with the superimposed line of an intaglio technique, whether that intaglio line is inked or uninked (an uninked line is called an emboss) is one of the most beautiful and attractive of all printmaking combinations.

Untitled, Myung Sook Chae, 2000. Etching and litho, 12 × 10 cm (4¾ × 4 in.).

Lithography and monoprint

Lithography combines seamlessly with monoprinting, as the two processes share the qualities of opacity and transparency of the drawing materials used to create their surfaces. The layers made in drawing during both processes create a variety of sympathetic marks and washes which marry effortlessly.

The image in the picture below was printed as several variations from the stone as it evolved. The extremely large stone used here belonged to the artist Anthony Gross. It had a pronounced dip in the middle from years of uneven graining. We worked for weeks graining this stone to prepare it for the artist to use, taking it in alternating shifts during each day of the graining process. What a thrill it was to finally lay a straight-edge diagonally across it and not see daylight!

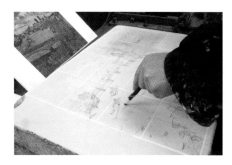

Above: Drawing the image onto the newly grained stone surface. A litho crayon pencil is used and a chalk grid has been sketched onto the surface to make it easier to scale the drawing to the stone's actual size.

Right: The artist Peter Spens at Artichoke Print Studio preparing a stone with an image for his exhibition Floating London, 2006.

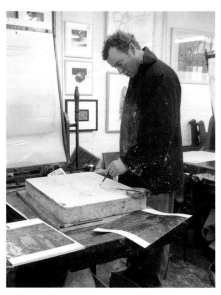

Stone lithography and screenprinting

The following image, *Magenta Cyan*, by Colin Gale, was made using a combination of stone lithography and litho film positives. The photo elements of each image were screenprinted onto the stones after each corresponding stone-litho image had been drawn and printed. These are the artist's notes on how the print Magenta Cyan was made:

Making the image Magenta Cyan

I made ten printings from a single stone for the image Magenta Cyan. Using CMYK colour registration tabs from commercial packaging as my image source, I made a photograph, then a negative, and then, as the screenprinting element of the image, the litho film positive.

Top: Area detail of overlay of some of the ten colours.
Above: Note the corner-shape impression the stone makes on the paper.

Magenta Cyan, Colin Gale RE, 1993. Stone lithograph, 76 × 112 cm (30 × 44 in.).

The combination of grease and water harmoniously working together based on their mutual antipathy has remained an enduring combination of elements. This unlikely pair intrigues and fascinates anyone in love with drawing, and guarantees that lithographic stones and grained plates – waterless plates and photolitho plates – and the humble sheet of lithographic transfer paper will still be in use for many years to come.

It is easy not to appreciate the scale of the matrix used when you are looking at the printed image. This picture shows the size of a stone as compared to a human hand. This is a medium-sized stone – they can be much larger.

Photolithography and linocut

The printed surfaces that result from these two printing processes work wonderfully together. The sharp and distinct shapes that can be achieved in both of these processes blend happily, so that it becomes almost impossible to tell which layer of the process is which.

The following sequence shows the second colour of the relief image being printed using a photolitho plate, with the relevant colour area needing to be added to the first colour, which has been printed from the lino block.

The photolitho plate with the image for the second colour to be printed on the lino is on the left-hand bed of the offset press. The lino is on the right-hand bed.

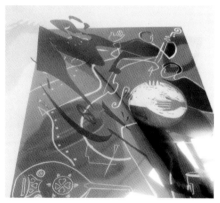

The registration acetate attached on the right-hand side of the right-hand bed has the image from the photolitho plate printed onto it. This means that the lino print can be located in the right position on the offset bed to allow the image from the photolitho plate to be rolled onto it precisely.

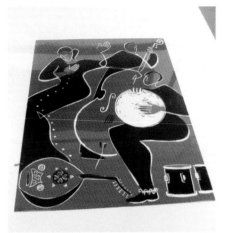

The white areas of the lino are lined up with the black of the same areas that have printed onto the acetate. This ensures that the lino print is in the correct position to receive the photolitho image.

Being careful not to move the lino print, masking tape is used to register the paper's position on the offset bed. The corner, the bottom and the left side of the paper are marked carefully so that the alignment is absolutely precise. The paper is secured in place with tape.

The roller is moved from one side of the offset press to the other. This picks up the inked image off the first plate, places it on the roller in reverse (mirror image) and then places it down again on the image on the second plate the right way around, or right reading – hence the term offset.

The completed combination print. The lino print has been successfully printed on top of the photolitho image. Hurrah. Let's print a hundred more!

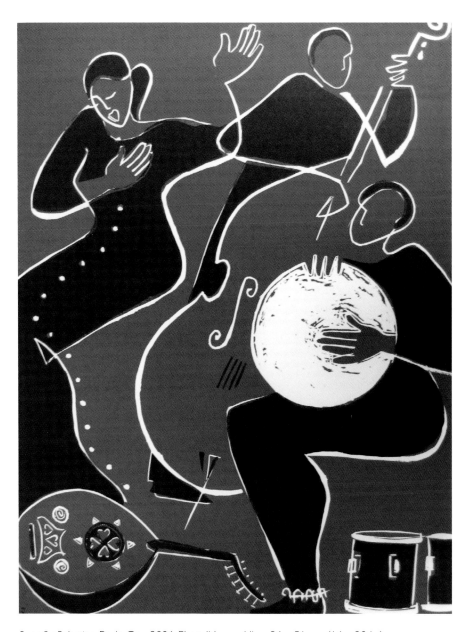

Song for Palestine, Paula Cox, 2006. Photolitho and lino, 36 × 51 cm (14 × 20 in.).

Litho-transfer drawing

Transferring information is crucial in the creation of most printmaking images. The combination of paper gummed with gum arabic allows the printmaker a lightweight alternative to carrying a heavy litho stone to a drawing site outside of the studio.

Grit, also called carborundum, is used as an abrasive substance to remove an image that is no longer wanted or needed from the surface of a stone. It comes in three grades – coarse, medium and fine.

The levigator is used to grind an old image from the surface of the stone. It effectively performs the same function as another litho stone used to grind away the surface image.

Graining or regrinding the stone erases the image from the surface. This is done using various grades of grit – coarse, medium and fine. The stone may be ground using another litho stone. The two stones are placed with their printing surfaces face to face, and the top stone is pushed around in a series of figure-eight movements, circular swings and passes over all areas of the bottom stone's surface as evenly and fluidly as possible.

The grit is washed away revealing a smooth, image-free stone surface.

The transfer drawing is placed on the stone surface and wetted generously with water from a sponge.

The stone with the wetted transfer drawing is run through the stone litho press. The pressure placed on the stone by the scraper bar forces the drawing onto the stone. You may have to put the stone through the press more than once for the drawing to transfer successfully.

The transfer paper is peeled back, revealing the drawing now on the stone.

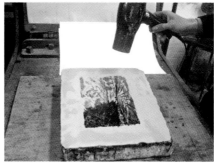

The stone is dried using a handheld leather flag or a hairdryer. The stone is then dusted with resin and then with chalk.

The stone is then etched using gum etches of suitable strength. The amount of fizz on the stone surface will indicate the strength of the etch.

Etches vary from weak etches (3 drops of nitric acid to 1 oz gum), progressing in strength (6 drops nitric to 1 oz gum) to a final strength of either 9 or 12 drops of nitric acid to 1 oz gum. The etch treats the relevant areas of the drawing. When etching the more delicate areas of a drawing, care should be taken that the etch does not burn the image and thus cause it to lift when the etch is removed (see the health and safety chapter for advice on how to handle acid safely).

Approximately an hour after this first etch the drawing can be removed (washed out) and replaced with printing ink.

After the first etch the drawing can be removed and washed out. Turpentine is used to gently wash out the image. Asphaltum (which is the 'washout') is applied to the stone. It is very greasy and is buffed onto the stone to reinforce the image. This greasy key makes the drawing very receptive to the non-drying black ink, called proofing black. This is rolled across the image using a leather nap roller. *Practical Printmaking* by Colin Gale and *Stone Lithography* by Paul Croft, both published by A & C Black Publishers, contain excellent in-depth information for prepping a stone-litho image.

The stone is then dried again.

Demo transfer drawing for stone-litho transfer, Rachel Lindsey Clark. 2008. 20 × 26 cm (8 × 10¼ in.).

INTAGLIO COMBINATION PRINTS

Within the discipline of printmaking there are six acknowledged traditional printmaking methods, and within those there are equally important printmaking methods which deserve to stand alone as techniques. Intaglio, which means to cut below the surface, is a diverse printmaking process in which marks are made on the printing plate by means of acid or with tools that actually cut the surface of the printing plate. The best-known techniques are etching, aquatint, sugar lift, soft-ground etching, hard-ground etching, drypoint, mezzotint and engraving, the last three of which are non-acid

Right: Steel plate in progress, 183 × 122 cm (6 × 4 ft), by Melvyn Petterson. The scale itself is one of the work's most fascinating elements.

Below: An etching plate in progress, 2008. The artist Melvyn Petterson has used a combination of etching processes and tools to make this steel-plate image.

techniques. **Please refer to the health and safety chapter for more information on how to use acid safely.**

Etching combined with aquatint remains one of the most popular combinations of printmaking techniques. Simple and elegant when put together, the images that the printmaker can fashion from combining these two techniques may contain many layers of considered tones or, equally, just a few marks of striking simplicity.

It may seem daft at this point to suggest a basic tip, but it is an important one. Combining intaglio processes has been happening since etching, drypoint and aquatint first emerged, and they meld together quite beautifully. But it cannot be stressed too often that the substrate surfaces must be

Aquatint is fun! Grounds lift, aquatints fail, photo emulsions repel from the surface – so take the time to degrease your plate. Aquatint box (pictured).

clean. Bar soft-ground etching, where the ground itself is naturally greasy, contaminated surfaces are the most frequent reasons for images failing to come to fruition. Whether it is a plate that is being used for traditional intaglio printmaking techniques or for a photo-intaglio process, or whether the plate already has an image in progress on it or this is a new plate for a new image, degrease it!

Grounds lift, aquatints fail, sugar lifts fall away, spit-bite remains ineffective, and photo-emulsions are repelled from the surface because of grease or trapped particles on the surface of the substrate that effect the contact between the surface and the emulsions and grounds. So take the time to degrease.

Degreasing an intaglio substrate

This procedure applies to a traditional substrate or photo-intaglio substrate (flexo plates are excluded). The plate should be dry if possible, so that the mixture of whiting and ammonia adheres to the plate properly and lifts the grease and dirt. The mixture should be a paste-like consistency, a bit like

toothpaste. If it is too loose and watery, it does not degrease the plate as well as it should. You can see this has happened when you come to rinse the whiting mixture from the plate: the water does not flow off the plate in a continuous unbroken sheet; it breaks and catches like eddies around rocks in a stream of water. Those rocks are the grease and dirt still on your plate surface. So you need to dry the plate and degrease again.

Combining whiting and ammonia for degreasing

The amount of whiting mixed should be enough to cover the plate evenly and creamily. Pile the whiting into a mound in the mixing tray.

Make a shallow hollowed-out shape in the whiting, as if you were making a small volcano. Pour the ammonia into the mouth of the volcano.

Top: Using a spoon, mix the whiting and ammonia together until it has the consistency of toothpaste. You may need to add more whiting or a touch more ammonia. It is better for the whiting mixture to be drier than it is for it to be too wet. The chalkiness of the mixture is what pulls the grease from the surface of the plate.

Centre: Put the whiting mixture on the plate with a soft flannel or small wad of soft cotton. Old press blankets are ideal to use for degreasing. Cut them into small hand-sized squares and have them ready.

Bottom: After thoroughly rubbing the whiting around the plate, including the edges and corners, rinse the plate under running water. The water should flow off the plate as a clean unbroken sheet; there should be no disturbances, breaks or pockets of open plate surface in the flow of water.

Bear in mind that steel plates will take a bit more time to degrease. It is advantageous to clean the steel on both sides with methylated spirits before you degrease with the whiting mixture.

INTAGLIO COMBINATION PRINTS

Left: Untitled, Claire Burbridge, 2000. Etching in wax, 76 × 66 cm (30 × 26 in.).

Above: *You Must be Joking*, Michael Roberts, 2007. Photo-etching and *chine collé*, 40 × 12 cm (16 × 5 in.).

Bottom: Sails 2, Jane Selman, 2006. Etching, aquatint and *chine collé*, 48 × 36 cm (19 × 14 in.).

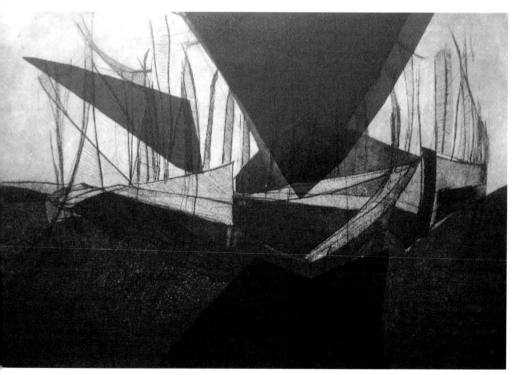

Combining hand-colouring and intaglio prints

Many artists combine hand-colouring with intaglio prints. Commercial prints have a long history of being hand-coloured. Hand-coloured intaglio plates, usually photo engravings, have been commercially published for many years. These images are unsigned prints from open print runs. Their value lies in the

Afternoon Shadows, Meg Dutton RE, 2006. Etching and aquatint, 50 × 37 cm (19¾ × 14½ in.). The hand-colouring in this hard-ground etching gives it warmth and luminosity which its title beautifully acknowledges.

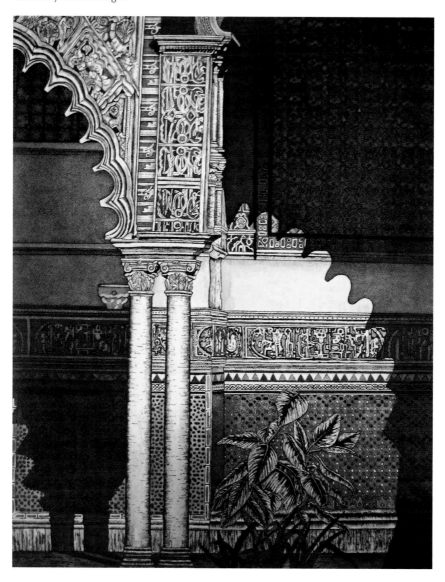

INTAGLIO COMBINATION PRINTS

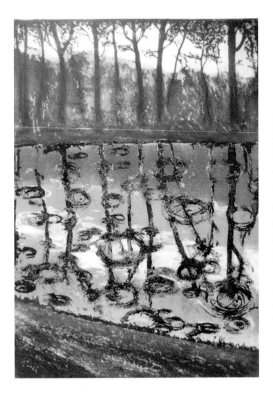

Canal du Midi, Pete Wareham, 2008. Open-bite etching and aquatint, 56 × 76 cm (22 × 30 in.).

fact that they are historical records of times and events that happened many years ago when artist-craftsmen took the time, or were asked, to draw and record them, or else were employed to copy paintings deemed to be of popular interest.

Hand-colouring adds a certain warmth and liveliness to a black-and-white image. Whether the monochrome image has tonal qualities or is purely line, hand-colouring refreshes and highlights chosen areas of the image (see detail with blue flower pn page 91). Alternatively, the image can be water-coloured or touched in with gouache to create a fully realised colour print.

Combining surface colour with intaglio

Combining surface colour with intaglio, or viscosity printing, is based on the idea that the marks on the surface of the plate are made at several distinct levels from each other. The process was invented by Stanley William Hayter, and it has gone on to be used by artists who have adapted it to provide not so much the elaborate layers he excelled at producing, but for surface rolling to complement a variety of plate surfaces. Indeed, the intaglio plate combined with the process of using a roller to roll ink over the surface as one does a relief print, known as rolling up, is irresistible once you see the result.

A thick ink is pushed into the lowest level of marks on the plate. A thin ink is then rolled onto the surface of the plate with a hard roller. Finally, a medium-thickness ink is rolled on top of those two inks. The plate with all three ink layers is then put through the press.

Surface rolling takes advantage of the layers of texture made on the plate, by covering the surface in a film of rolled ink, when printed this creates beautiful colour combinations in the printed image. The layers of texture on an intaglio plate are achieved with acid, which bites into the surface of the plate.

These are steel etching plates which have been stopped out and bitten in a very strong nitric-acid bath for a very long time (approximately two hours).

Details of the textures that can be achieved with stop-out varnishes, straw-hat shellac varnish and wax grounds on the plate.

It is a mistake to think that a fiercely strong acid bath will render an image quickly on any type of etching plate. It is both dangerous and a waste of materials – both the metal and the acid. It is safer and much more practical to use a milder acid ratio for a longer period of time – for example, 6:1, meaning six parts water to one part nitric acid. **Please read the health and safety chapter for safe procedure when using acid.** This ensures that the image is not ripped clean off the surface so that you are left with nothing. The milder acid will still follow the guidelines that your stopped-out image has created, but will not distort and disfigure them. This is especially true with zinc and steel. The action of the acid biting the surface of both these metals means that lines get wider. The acid bites across the plate. On copper, the ferric acid used bites down into the plate, so the lines stay a fine and consistent width for quite a long time before they begin to be corrupted.

Etching and emboss

Combining intaglio processes leads to an exciting range of surface textures in the print. Combinations of printing processes accentuate the effects of both the raised and depressed surface working together on the paper surface, and can create beautifully effective contrasts of depth and shape.

Deeply bitten plates are a key component in successful embossing, whether the plates have been inked or left uninked. Properly damped and blotted printing paper is another important factor. The next choice is whether to use the plate inked or uninked. If you choose to ink the image, you can apply ink to the surface of the plate both with intaglio inking and with surface-rolled ink. This combination of printmaking techniques is one of my own personal favourites.

The American Dream, Erika Turner-Gale, 1992. Emboss, 20 × 20 cm (8 × 8 in.). Many types of plates can be made to be used to create an embossed texture in the printing paper.

The following picture shows a plate being surface-rolled and printed.

The artist Morgan Doyle works on steel etching plates of great size. This particular image is a steel-plate etching. The artist used open-biting in nitric acid (ratio 8 parts water to 1 part nitric acid) to create the image. He inked and scrimmed the etching plate in the normal way. The surface-rolled ink colour is not rolled on too thickly, as this would cause it to be pushed out from its designated image areas when the plate is printed. A plate

Rollers of different sizes were then used to roll on surface colour in various image areas on the plate.

that is loaded too excessively with surface-rolled colour may bleed off the plate and outside of the paper margins or onto the blankets. Care should be taken when printing surface-rolled plates.

The dampened printing paper is held above the plate, now on the press bed, and lowered carefully. With a plate this large it is wise to have someone handle the paper drop with you. This ensures that the paper is dropped straight onto the plate, and doesn't flap and fall onto it, thereby dirtying the paper or needlessly marking the inked plate surface.

The plate and printing paper are run through the press. The paper is slowly removed from the plate surface to prevent it from tearing or ripping if the stickiness of the inked surface proves adversarial.

Above: The plate is placed on the bed of the press. The press bed is 7 ft × 3 ft.

Right: The printmaker Morgan Doyle, with the printmaker Judith Clute, removes the finished print and places it in the press bed.

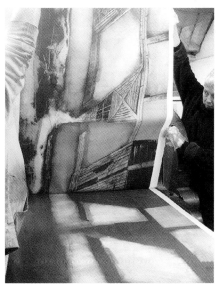

The finished print on the press bed. Courtesy of Morgan Doyle, 2008.

Chine collé and intaglio combinations

Chine collé is a process in which separate thin sheets of paper that have been glued are placed, glue side up, on a substrate to enable them to be printed into an image on paper. The *chine collé* paper may be hand-coloured, of a certain texture, shape and size, and either torn or cut. It becomes part of the print as the adhesive and the pressure of the printing press bond this second layer of paper to the surface of the paper onto which it is being pressed. The *chine collé* may be of any size: it can extend beyond the

Above, right: A detail of an etching plate combined with *chine collé*, courtesy of artist-printmaker Michael Roberts.

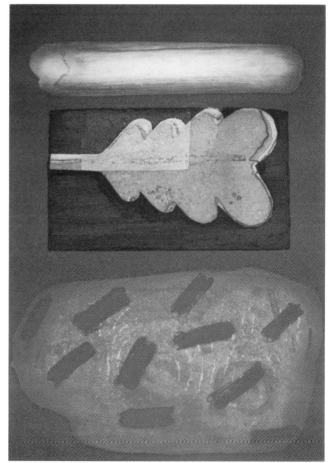

Untitled, Sarah James, 1994. Etching and *chine collé*, 20 × 18 cm (8 × 7 in.).

INTAGLIO COMBINATION PRINTS

Sunrise, Megan Fishpool, 1994. Digital print and digital *chine collé*, 20 × 26 cm (8 × 10¼ in.).

plate mark made by the plate or it can highlight one small particular area of the image. It can be a simple shape torn from coloured tissue paper, an elaborately textured Indian paper, metallic sheets such as silver or gold leaf, pages from books, musical manuscripts, good old reliable newsprint or telephone-directory pages. Not all these papers are archival, but that is not always a priority when pursuing how you want an image to be made.

Combining *chine collé* with a photo-etching plate

The intaglio plate is inked as it would normally be inked, then scrimmed and polished with tissue where highly clean areas are desired. The intaglio plate in this sequence is a photo-etching on a copperplate. It is inked in black printing ink.

Black etching ink is carded onto the etching plate, then scrimmed and any highlights wiped with a tissue before the *chine collé* is applied.

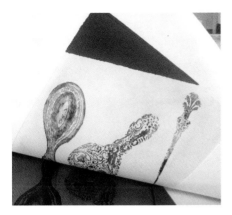

The addition of *chine collé* can add a moment of drama to the image, or create a focal point, or act as a suggested shape or object.

The image in this picture sequence is further developed with the addition of silver leaf to the brush shapes in the etching.

The chosen *chine collé* paper is torn to the required shape. The glue is placed on the side that is facing the printmaking paper you will drop onto the plate. This means that the glue is facing upwards and not towards the plate surface. It will cause much merriment if you forget this, as the pressure of the roller will laminate the *chine collé* piece quite effectively to the surface of your plate instead of your intended paper. Not funny, if it's the very last bit of your favourite *chine collé* paper and you will never be able to return to Tibet to get more.

Buttons and Hooks, Jo de Pear, 2005. Photo-etching with *chine collé* and silver leaf, 112 × 66 cm (44 × 26 in.).

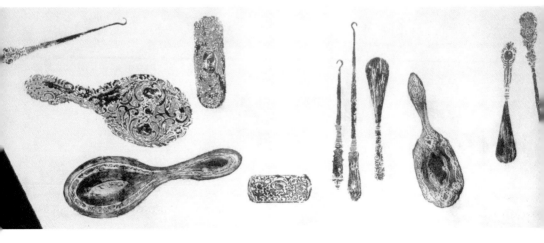

SCREENPRINTING COMBINATION PRINTS

The earliest screen prints date from as long ago as 30,000BC – hand stencils at the Lascaux Caves in France give evidence of this; hence it is probably no accident that there is a range of water-based screenprinting inks using the name Lascaux. The Chinese are historically recorded as the first proper users of stencilling; they used this method for commercially mass-producing religious icons.

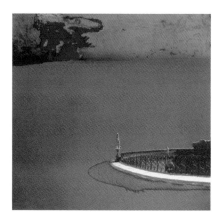

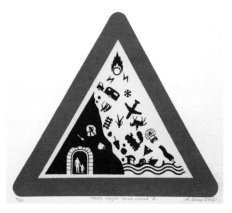

Untitled, Nina Pope, 1992. Screenprint and digital, 28 × 28 cm (11 × 11 in.).

There May Be Trouble Ahead, Martin Grover, 2007. Screenprint, 36 × 36 cm (14 × 14 in.).

Screenprinting combines very well with a multitude of artistic contexts: sculpture, ceramics, photography, digital imagery, installation art and any of its printmaking brethren – relief, intaglio, monoprint, collagraph and lithography processes.

With the introduction of water-based screenprinting inks, screenprinting has become a much safer, more user-friendly process. Colleges, schools, and professional and private studios alike, take advantage of the health and safety benefits that water-based screenprinting methods offer, to the extent that it is virtually impossible nowadays to find oil-based screenprinting being used anywhere except in fine-art studios and educational institutions.

Cut and drawn stencils are the traditional ways in which the printmaker creates an image with a screen. These are usually hand-drawn or handmade.

The advent of the computer age introduced the photographic stencil. Handmade or hand-drawn stencils have been largely superseded by the photographic/digital stencil because of both the speed and flexibility of

The screen, emulsion and squeegees.

A selection of water-based ink colours.

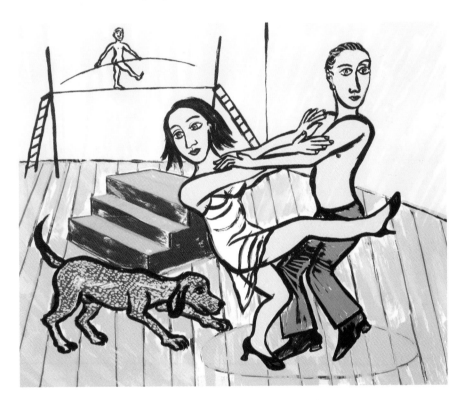

Tango, Eileen Cooper, 2004. Screenprint, 56 × 78 cm (22 × 30¾ in.).

printing equipment in outputting the source material. Synthetic surfaces and colours have also been developed, especially in the commercial industry, and these are readily available for the fine-art printmaker to use. The photographic stencil is often more cost-effective for the printmaker, and even if this is not the case, the accessibility of computer software programs, inputting equipment (scanners and digital cameras) and outputting equipment (inkjet and laser

Portrait 111, Megan Fishpool, 2008. Monoprint and photo screenprint, 54 × 54 cm (21 × 21 in.).

Cathedral, Megan Fishpool, 1988. Photoscreen collage, 56 × 76 cm (22 × 40 in.).

printers) make them the preferred option.

The development of light-sensitive mesh or mesh that can be coated with light-sensitive photographic emulsion improves the convenience and speed at which an image can be rendered. Most artists appreciate this aspect. With the introduction of water-based screen inks the commercial printing industry has given a positive nod to health and safety concerns and made available a safer and more economical technique for the individual artist-printmaker to work with in the studio.

It is a bonus to have a UV light box in the printmaking studio. It makes possible the transfer of imagery onto light-sensitive matrices. Meshes combined with light-sensitive emulsion have made it possible to transfer photographic imagery, digital imagery and autographic imagery. These prepared meshes are called photostencils.

There are two basic types of photostencils that artists can work with: direct and indirect. An indirect stencil is made by exposing the image onto a film with light-sensitive emulsion so that it can be placed on the mesh after it has been exposed, creating a positive of the negative.

A direct stencil is made by placing it in contact with the mesh and exposing it; when the soft emulsion is washed away the hardened image areas remain.

The following pictorial sequence uses the direct stencil to demonstrate how a screenprint can combine with another printmaking technique to

build up a final image. The artist-printmaker Scarlet Massel generously shared her time, studio and equipment for the demonstration. Her screenprinting studio uses only water-based screenprinting products.

An etching, relief print and monoprint were chosen as the three printmaking techniques to combine with a screenprinted element to complete the image. The screenprinted element was made to complement all three of the prints used in this sequence.

The screenprinted image is an autographic mark on drafting film made with opaque black drawing ink. The drawing ink was allowed to dry completely. This is to ensure it does not stick to the surface of the screen mesh due to the force the vacuum exerts on the surface of the screen during the exposure time in the UV light box.

Preparing the photo screen:

STEP I

A The screen, the emulsion trough, light sensitive emulsion, and scraper.

B The photo-emulsion is poured into the trough.

C The red safety light is on and the trough is positioned at the base of the screen. The trough is the same width as the chosen screen.

D The trough is tipped and slowly drawn up the face of the screen in one single fluid motion. The photo-emulsion evenly coats the entire surface of the screen.

A

B

C

D

Step 1: The screen is coated with the light-sensitive photo-emulsion. Note that the safety lights are on in this sequence. The photo-emulsion is poured into the coating trough. As it is tipped the emulsion is flooded evenly across and up the mesh in one single, fluid and quick movement.

Screen meshes have different grades, denoting their thread count. 90T and 120T are recommended for water-based screenprinting. The mesh used for this printing sequence was 90T (standard thread diameter).

Step 2: The image to be exposed onto the screen is placed on the glass top of the UV exposure unit. The screen is placed on top of the image. In this instance, the drafting-film image is given 165 units of exposure time (note: safety lights should be on).

STEP 2

The top of the UV light box is raised. The light box has been on for several minutes to ensure that the bulbs are all of an even light consistency.

The screen with the applied photo-emulsion is placed on top of the image drawn on drafting film, which has been placed on the glass top surface of the UV light box.

The drawn image which will appear on the screen after exposure can be seen through the mesh of the screen.

The UV light box timer is set. The exposure time is based on units of light.

Step 3: The vacuum is turned on. This ensures the crucial contact necessary between the screen surface and the image source material. The start button is pressed and the countdown of the 165 units begins.

This exposure time is for 165 units of light.

Step 4: The screen is sprayed with water, rinsed and dried. This reveals the image area that has now been hardened onto the mesh.

The screen is sprayed with water, rinsed and dried.

Step 5: The screen is placed on the screen bed and clamped into place. Squeegees are chosen of the appropriate length for the image to be printed.

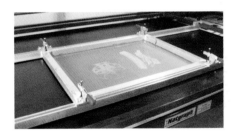

The screen is placed on the screenbed and clamped into place.

Step 6: The registration tabs for the paper are put into place, and the areas not covered by the image on the screen bed are covered with newsprint to block out any exposed vacuum holes.

Registration tabs for the paper are put into place.

Step 7: The ink colour is mixed. In this instance, the yellow ink used is water-based. Water-based inks dry very quickly, so once you begin printing, you must remember to work quickly to prevent the ink drying in the mesh and clogging it.

A The ink colour is chosen. **B** The ink colour is mixed.

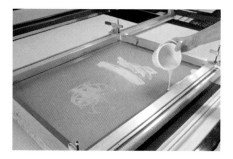

The ink is poured along the inside of the bottom gummed, masked edge of the screen.

Step 8: The ink is poured along the bottom gummed, masked edge of the screen. It acts as a reservoir until you flood the screen with ink with the squeegee. The screen is raised so that it doesn't make contact with the paper on the bed base during the first flooding of the screen. The squeegee is drawn up from the bottom of the screen to flood the mesh – draw up to the top from the screen edge closest to your standing position. The test sheet of paper put into place within the registration marks can now be printed on. This is the first proof, pulled to check that the image prints clearly and precisely. If this is satisfactory, the printing of the image can go ahead.

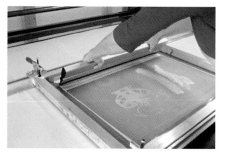

Use an even, firm pressure when flooding the screen.

Step 9: The squeegee is drawn back down the length of the screen using even pressure. Place your hands on the squeegee comfortably wide apart, with your fingers splayed to ensure a steady, even, consistent grip as you move the squeegee across the surface of the mesh.

Step 10: The image on the screen now appears on the woodcut image. One pull is sufficient to create a strong mark on the woodcut image. The printing continues so that the same screenprinted image is placed on the etching and the monoprint.

The woodcut is seen here on the screen bed next to the proof of the screenprinted element still to be added.

The etching is seen here on the screen bed next to the proof of the screenprinted element still to be added.

The monoprint is seen here on the screen bed next to the proof of the screenprinted element still to be added.

The monoprint on the screen bed. The new yellow image layer has been screenprinted onto the previous image.

Step 11: The squeegee is cleaned and put away.

The squeegee is cleaned immediately.

Step 12: The screen, while still on the screen bed, is cleaned immediately with a general all-purpose, water-based household cleaner such as Mr Muscle. Water-based inks dry very quickly. Being polymers, like acrylic paints, once they harden they can ruin a good screen. The screen is now ready for the final clean using a high-pressure water hose.

Mr Muscle is a studio-friendly, water-based cleaner for water-based screen inks.

Step 13: The screen is placed in the blasting sink so that it can be blasted clean with a pressure hose. **Ear goggles and a plastic apron should always be worn for this task.** When this is done the screen is dried and put away.

A high-pressure water hose is used to blast the screen completely clean.

Screenprinting often gives an image a very graphic look. It is a process where the layers of colours are incredibly apparent in the design of the image, one of the visual elements that give it its distinctive appeal and panache. But it is also a technique that can be used to render layers quite subtly. In this respect, accurate registration is crucial to the literal rebuilding of the image being made, as more often than not an image being screenprinted is composed of a number of different printing layers.

This layering lends itself well to the image-layering tools in programs such as Adobe Photoshop® or Illustrator®. Programs like these are good to experiment with for an artist interested in making a screenprint, assuming they have access to a computer. An image can be altered and outputted as a positive, or positives, if a four-colour-separation image is needed.

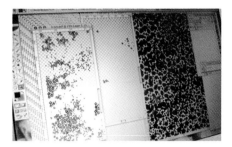

The cut-away layers are used to make the positives to rebuild the image.

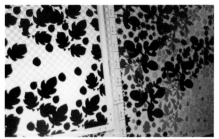

A single-shape layer next to a layer of the entire range of shapes that make up the image.

The image is saved as layers.

Symbols and Layers menu.

The image is saved in layers – so that the original image can be broken down into as many colours as the artist requires. Every layer equates to a screen, and a positive can be outputted for that particular layer/colour. The image is slowly rebuilt in layers until the initial image is complete again, but as a screenprint.

Adobe Photoshop® is an outstanding picture-manipulation software program. For more information about using it, please see *Practical Printmaking, Digital Printmaking* and *Water-based Screenprinting*, all titles in the A & C Black printmaking handbook series, which provide excellent useful additional information.

Alternative substrates to combine with screenprinting

Screenprinting as a process is open to all kinds of creative possibilities. In the above image, mezzotint has been combined with digitally created *chine collé*. Try screenprinting directly onto an etching plate – steel, copper or zinc (though remember that the metal will need to be degreased) – or onto acetates or Perspex, fabric, plywood, MDF, alternative papers (newspaper, carborundum-

SCREENPRINTING COMBINATION PRINTS

Aboriginal, Scarlet Massel, 2007. Silkscreen and digital print, 102 × 152 cm (40 × 60 in.).

Bus Ticket, Colin Gale, 1989. Stone litho with photoscreen, 76 × 112 cm (30 × 44 in.).

coated paper, wallpaper), the entire side of a building, the inside of a building, and, as nothing is set in stone … why not stone! Please see the chapter on Lithographic Combination Printing, page 78, for the sequence describing stone lithography and screenprint combination printing.

Clapham Junction, Ray Gale, 2008. Hand-cut paper stencil and final photostencil for line work, 50 × 40 cm (20 × 16 in.).

Dimension (Red) & Dimension (Grey), and Meridian (Grey) & Meridian (Blue), Ray Malone, 2006/7. Screenprints, image size of Dimension prints is 75 × 75 cm (29½ × 29½ in.), and of Meridian prints 70 × 70 cm (27½ × 27½ in.). All screenprinted by Sally Grimson at Artizan Editions, courtesy of the artist.

It is always fascinating and intriguing to read why an artist creates an image. What is often unknown to the viewer is how long it can take an artist to bring an idea to fruition. The artist Ray Malone told me about his screenprinted images illustrated here.

As to the history, both sets of prints originate from paintings, the Dimension set from a series entitled Dimensional Paintings, and Meridian from paintings of that name.

In both cases, I drew the templates to scale and Sally Gimson cut the screens, and then we worked together on the colours, based on the colours I use in the paintings. So, in neither case are they copies or reproductions of paintings. The first set was made in 2006, and the Meridian set is about to be printed and signed off, though we worked on them last year (2006).

RELIEF PRINT COMBINATIONS

Woodcut, wood engraving, card cuts (also known as collagraph), linocuts, stamps, letterpress, frottage surfaces and stencils are types of relief printing.

All these methods transfer an image to a printing surface via the action of inking the areas of the design that are raised on the surface of the substrate, which the ink will highlight when applied. Rollers, dabbers, stippling brushes and spraying are all ways of applying ink to specific types of relief surfaces. Inking the surface with a roller is the most universal way to apply colour.

Letter monogram stamp for embossing wax/butter stamp press.

Vintage textile blocks. The shaped block on the far right is an early Victorian textile block.

Stencils can be hand-cut or laser-cut.

Wooden letterpress letters.

Metal type – note the varying type sizes.

RELIEF PRINT COMBINATIONS

Rhino (detail),
Jane Bristowe,
2007. Linocut,
33 × 33 cm
(13 × 13 in.).

Tate Burgundy, Paul Catherall, 2003. Linocut, 46 × 90 cm (18 × 35½ in.).

Childhood stamping kit: a box with alphabet, numerals and cartouches (the ink has long since been used).

The linocut

The linocut is relished for its bold, graphic images. Most linocuts do not contain fine lines.

The tools used to cut lino have different-shaped cutting blades to produce different marks. Their tips are called nibs. A gouge gives a scooped line for large white areas.

A gouge = scooped line for large white areas
A V-shaped = lines of varying thickness
A fine tool = stippled and cross hatched areas
A knife edge = clean edges

An assortment of nib style economy lino cutters.

Reduction linocut

The reduction method is where the same block is used, and cut away for each colour necessary to print the design. This approach obliges you to plan your design beforehand and also to print as many proofs as you think you will need, as you cannot reprint the first colour again once the block has been cut away.

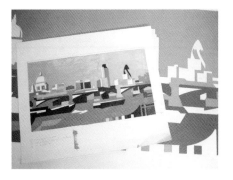

The artist makes a key drawing, which confirms the shapes to be cut, and the colours of the design to be used.

Registered linocut

This method of cutting is where a series of blocks are cut, one for each colour necessary to make up the completed design. The most popular way of registering a series of lino blocks is to use blocks that are exactly the same size, meaning that all of the blocks can be printed in exactly the same position. This method of printing does require you to print the first colour for the entire edition, before proceeding to print the next colour. Then you do the same with the second colour, and the third, and so on.

Pallant House, Paul Catherall, 2007. Registered linocut, 27.5 x 20 cm (10¾ x 8 in.).

The first colour of the design.

The second colour of the design has been printed.

The third colour of the design has been printed.

The fourth and final colour of the design has been printed.

Printing a registered multiblock linocut

The following image sequence shows how a two-colour lino image is printed:

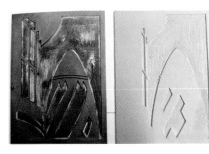

The two blocks have been cut for the two colours that will make up this image.

The lino block that will create the grey area of the image is rolled up in grey ink.

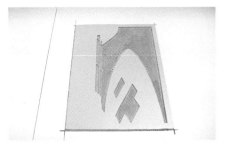

The paper is placed onto the inked block, using the registration marks made for the paper size. The lino block fits within the paper-area registration marks with equal margins around all sides. The first colour is printed.

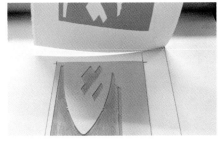

The lino block inked in grey is placed on the bed of the press.

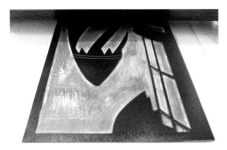

The second lino block is inked to create the second colour of the image.

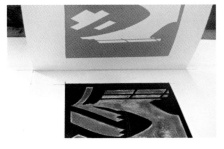

The block is placed within its registration marks and the paper placed over the inked block, using the registration marks for the paper size marked out to create equal margins around the image for each subsequent printing of the blocks.

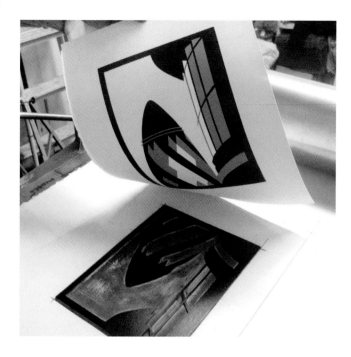

The finished two-colour print is revealed.

The lino-print image used in this sequence is *Gherkin*, courtesy of the artist, Paul Catherall, 2005, linocut, 24 × 18 cm (9½ × 7 in.).

Combination printing with relief processes

Relief print and intaglio print

Combining a relief print with etching can create very dramatic images. The hard graphic boldness of a relief print is an effective accent when used with a crisp and authoritative etched line.

The image in these pictures illustrates how the intense red relief elements bring alive the image, by highlighting the circular design of the etching's composition.

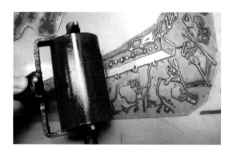

The laser-cut titanium relief plate is inked.

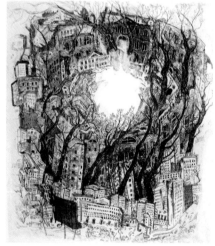

The etching before the relief print has been printed on top.

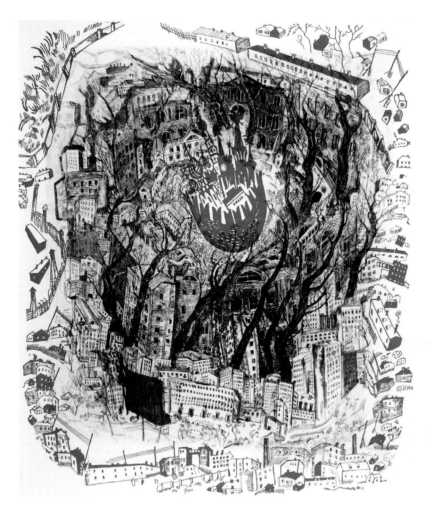

The final print. *The City*, relief etching from the artist's book *The Wasteland*, Maxim Kantor, 2002, 56 × 72 cm (22 × 28¼ in.).

The Artists Choice

Printmakers choose to combine different printmaking techniques for many reasons. Some of those reasons are technical, some are creative – but once chosen those techniques interact with each other – and the image takes on its own unique identity.

The resulting print is something that the viewer enjoys as a picture. How we make prints involves techniques, which are both complicated and specialised, and techniques, which are basic and straightforward. If prints are mystifying, puzzling or even enigmatic it is a compliment to the printmaker's skill and creativity.

Jumping In Puddles, Staffan Gnosspelius, 2006. Collagraph and *a la poupée*, 20 × 20 cm (8 × 8 in.).

Vladimer Myakovsky and Lily Brik, Kate Boxer. Drypoint and *chine collé*, 75 × 74 cm (29.5 × 29 in.).

Petit Mort 5, Marcelle Hanselaar, 2006. Etching and aquatint, 18 × 23 cm (7 × 9 in.).

Firepower, Phil Solly, 2000. Copper engraving and power tools, 25 × 25 cm (10 × 10 in.).

Registration for lino using an intaglio plate

Transferring an intaglio image onto a lino block to aid in the progression of the cutting of the design is an alternative way of placing a detailed image on the cutting surface quickly. The inked proof is placed on the clean, unmarked lino block and printed onto it. Dust this inky image with chalk. You now have a guideline to use, which will be helpful in showing you the necessary elements of the design.

Offsetting a proofed image from one printing substrate to another is a practical registration technique. It can be used for offsetting both intaglio and lithographic images, as well as relief images.

The following sequence shows an inked etching plate and the proof from that plate being offset onto a lino block. The block can then be cut using the detailed information that has been transferred onto the lino block from the etching plate.

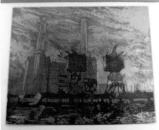

The etching plate is inked as normal for printing and the surface of the lino is cleaned of any grease. Methylated spirits are ideal, or, if you do not want to involve solvents in your cleaning procedures, a thick mixture of baking soda and water.

The inked copper etching plate and the clean, uninked lino block.

The clean lino is placed on the bed of the press, and the freshly pulled inky proof from the etching plate is positioned on the lino.

A tip for positioning the image correctly on the lino is to have the lino cut to the size you want it to be. Tear the still very inky proof down to the borders of the printed image. This gives you the actual size of the image, which you can use to position the paper correctly on the lino.

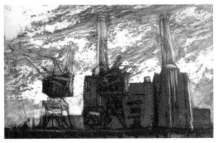

The inky image on damp printing paper torn down to the edges of the image.

The inky proof and clean lino are run through the press together.

The image from the proof is transferred onto the clean lino surface. It is best to dust the surface of the lino with chalk to keep it from smudging.

Left: You now have a detailed template, which you can use to cut the image into the lino surface.

Below: When you have finished cutting the lino, ink and print the image. *Battersea Powerstation,* Pete Wareham, 2008. Lino. 20 × 26 cm (8 × 10 in.).

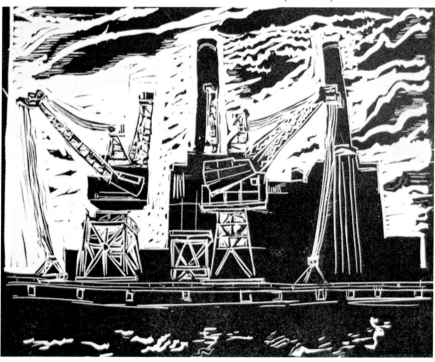

This method can also be used to transfer the image from one lino block to the next to aid in the progression of the design during cutting. Make your first block and take a proof of it. The inked proof can then be placed on the next clean, unmarked lino block and printed onto it. Dust this inky image with chalk. You now have a guideline to use which will be helpful in showing you the positions of earlier elements in the design.

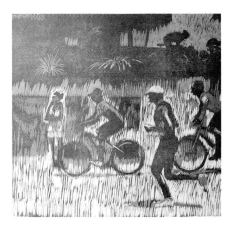

Woodcut combination printing

The woodcut is loved because of its surface, and allows greater detail than the linocut, because of the distinctive variations of surface grain.

A single cut block of wood combines beautifully with monoprinting.

Above: *Runner and Cyclist*, Adrian Bartlett, 2007. Woodcut. 41 × 46 cm (16 × 18 in.).

Below: *Captives*, Poppy Jones, 2007. Woodcut monoprint, 2 panels of 56 × 76 cm (22 × 30 in.) each.

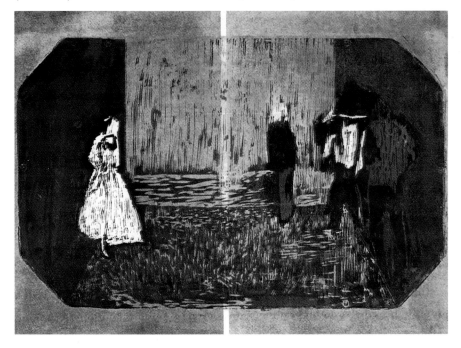

Woodcut and intaglio

Woodcut tools vary in shape, and a chisel and gouges are used with a mallet to cut the block.

A selection of equipment used for cutting wood: wood (size and grain of your choice), V-shaped tools, gouges, small-headed hammer for removal of large areas, sandpaper and retractable knife for cutting lines.

Woodcut, etching and plate lithography

The relief technique works well when combined with photo processes. This picture shows a new image by Colin Gale in the process of being made.

The strength and clarity of the wood's surface grain in this image has been inked in bold colours. The cut areas are partitioned so that they join seamlessly, while at the same time allowing the final image to flow. The heavy steel registration blocks put weight onto the joins of the jigsaw-cut wood shapes, keeping the separate parts from moving around (see picture) as the new areas of the image are designed. The artist plans to print the woodcut in combination with a photo-etching plate, which at the time of writing was in the process of being drawn.

The relief technique works well in combination with photo processes as well as traditional processes. This picture sequence shows a combination relief image in the process of being made.

The image is composed of three processes, woodcut, etching and plate lithography. There are four plates to be registered to create the final image. The first elements of the image are the woodcut and etching stages. Two woodcut blocks have been made and an intaglio plate.

The jigsaw pieces of the first woodblock are inked individually and

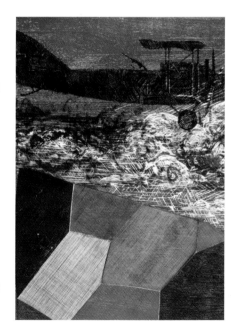

Sagitarius Rising, Colin Gale RE, 2008. Woodcut and photo-etching, plate lithography 76 × 112 cm (30 × 44 in.).

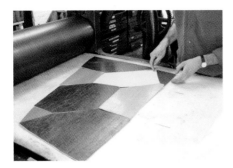

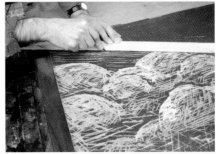

The first woodblock has been jigsawed into separate pieces which are individually inked in different colours.

The second woodblock has been cut with gouges and v-shaped tools. This block is inked in a single colour.

then placed together again. They are printed onto dampened printing paper. The intaglio plate has been inked *a la poupée* in colours to complement each section of the same shaped woodblock it will register with.

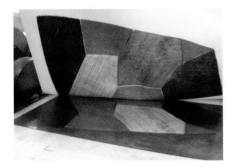

The inked intaglio plate is printed on top of the multicolour woodblock stage.

This picture shows the proof with the second woodblock printed in combination with the first woodblock and the intaglio plate.

The strength and clarity of the grain of the wood's surface is enhanced in this image by the bold ink colours used. The intaglio plate image uses colours which contrast yet complement the colours of the woodblock.

The second woodblock is inked and printed on top of the first two stages. The vibrant magenta accents the sky and horizon of the image.

The next stage of the image is the lithographic plate. The image is hand-drawn onto a prepped zinc litho plate. The image is first drawn onto draughting film with a 2B pencil. This makes it possible to use the draughting film as a template to make a chalk image on the litho plate so that the chosen lithographic drawing material can be used to initiate the image.

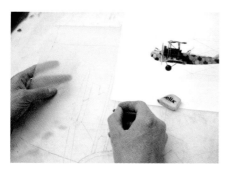

The image for the fourth plate is first drawn onto draughting film.

The image is traced down onto the prepped lithographic plate using chalk.

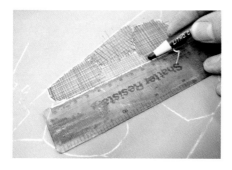

The artist has chosen a lithographic pencil to use for the image on the lithographic plate.

The lithographic drawing in progress, which will be used in the print.

The artist printed the woodcut in combination with the etching plate and the lithographic plate. The three combined processes complement the striking subject matter of the print.

PVC and acrylic relief blocks

PVC blocks and acrylic sheets now provide printmakers with alternatives to the traditional lino surface.

Bought hardwood blocks, which are available pre-polished on both sides, are available from suppliers such as Intaglio Printmaker (see the list of suppliers at the end of this book). An alternative surface is Perspex or acrylic/PVC sheet, which

Traditional lino next to plastic lino.

can be mounted on MDF board or on several sheets of laminated cardboard.

However, the cut marks on these materials, while acceptable, are not as smooth as on the hardwood.

Woodcuts, woodblocks and linos can be printed using conventional relief presses such as an Albion, Columbian or sprung-roller press such as the Karsten Berglin press used at Artichoke Print Studio, or they can be printed by hand using a burnisher or the back of a wooden spoon.

Handheld burnisher, wooden spoon.

Alternatively, as some artists do, try full-bodyweight burnishing. This is recommended for woodcuts that are life-size or larger, and also for improving your calf muscles!

Burnishing a print using the 'jumping' technique. It leaves a good impression on the print, and keeps the legs shapely.

3D AND 2D:
ARTIST BOOKS AND CONSTRUCTIONS

A 3D print is really a 2D matrix with the added illusion that you can actually move into and around the image. Surface is combined with dimension (e.g. height, width and depth). Any object that has a printable surface can become a 3D print: ceramics, glass, clothing, the space in a computer software programme.

Printed constructions may also involve movement, either with motion enabled parts or the ability to be interacted with by opening or closing, turning or pulling the print.

A 3D print has the capability to be viewed from a multiple of vantage points A construction print is a 2D image that needs to be mounted, supported, or attached, or layered to or in a matrix, so that though it has the qualities of 3D it's visual accessibility is not totally necessarily dependent on being seen from multiple vantage points.

The following sets of pictures illustrate this distinction. *Torso*, by Carole Hensher is a 3D print and *Woman's Work* by Tom Phillips and *Jump*, by Mick Davies are construction 2D prints.

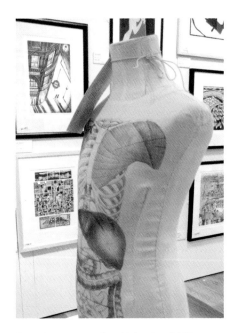 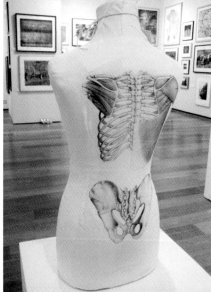

Torso, frontal view, Carol Hensher, 2007. Back view.
Photolitho on cloth mannequin, 91 cm
(36 in.) high.

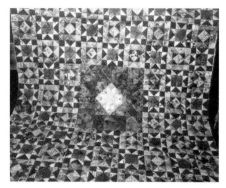

The combination of the 2D print with a structure/object can produce spectacular results.

Above: Woman's Work (detail), hand-made by Alice King and Alice Wood with Tom Phillips, 1997.
Below: Woman's Work, hand-made by Alice King and Alice Wood with Tom Phillips, 1997. Paper and cotton fabric, 204 × 204 cm (80 × 80 in.). Photo courtesy of Paul Tozer.

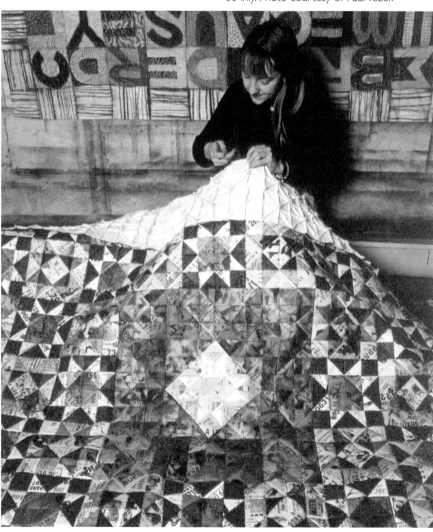

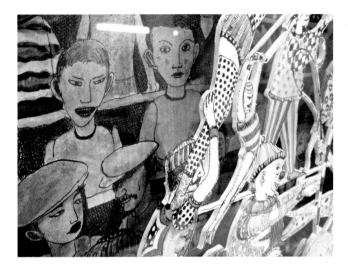

Jump, Baby, Jump (detail), Mick Davies. 2008. 3D Photo-etching construction on foam board, hand-coloured.

The final object incorporates traditional elements of printmaking with an ingenious and simple design. The cut out print pieces create a provocative freestanding composition which has foreground, middle-ground and background with great success.

Artists' books rely heavily on both the elements of 3D and 2D multiple layers of printed information to create their visual impact.

"There are no absolute rules for producing artists' books; the process you use to make your edition is entirely up to you." Sarah Bodman, Creating Artists' Books, A & C Black Publishers, 2005.

Commercial and industrial inkjet printers are becoming more and more popular with printmakers in the production of their images. Almost all of the inkjet printers made today use the piezo process. A piezo inkjet head or nozzle, differs from a traditional thermal inket nozzle or inkjet head in the way that it pulses or creates the necessary pressure to produce the ink as a droplet. Piezo inkjets work on the principle that droplets of ink fluid are forced from the nozzle via an electric pulse rather than a heated element. This means you can have a greater variety of ink cartridges in the printer printing your image; six or eight colours at the same time instead of only four.

Book artists can take advantage of the exceptional standards that inkjet printers now offer as the picture on page 129 illustrates, *Heroes and Villains*, by Magnus Irvin.

And the idea of combining traditional printmaking techniques is still valid and exciting. The project that the artist Maxim Kantor undertook at Artichoke Print Studio involved making a set of artists' books. The first title, *The Wasteland*, was composed of seventy images, 56 x 72 cm in size, and each individual image was editioned to seventy-five. The images were made as hand drawn hardground etchings with aquatint on copper and then hand-stamped

Heroes and Villains, Magnus Irving. Seven Piezo prints with accompanying text, as box set.

with a relief image on top of the intaglio image. It was a phenomenal task which took two and a half years to be completed by three professional printers. As soon as that book was completed he began the second book *The Metropolis*, which was the same size and format – a portfolio book of seventy images each as an editon of seventy-five. Each image combined the printmaking processes of multi-plate offset photolitho, hard-ground etching and aquatint.

Above: The Wasteland, Portfolio Box with handpainted cover image, Russia. 56 × 72 × 7.5 cm (22 × 28 × 3 in.).

Left: The Wasteland, Maxim Kantor, 2002. Comprising 70 images of etching, aquatint and relief, edition of 75. Printed at Artichoke Print Studio.

Mai Mountain, Myung Sook Chae, 2001–2002. Stone lithography and emboss, number 16 from an edition of 25, 12 × 9.5 cm (5 × 4 in.).

Prints by artists can also be created as original prints to be used as images in books for publication by a commercial publisher.

Original collagraph/etching for *Mister Räf!*, Staffan Gnosspelius, 2007.

The book, *Ga och bada, Mister Raf!* Staffan Gnosspelius, 2007. Published by Opal, Sweden.

The book *Chip Crockett's Christmas Carol*. Original etchings by Judith Clute. The book was published in 2006, in a limited edition of 222 numbered copies and signed by both the author and the artist.

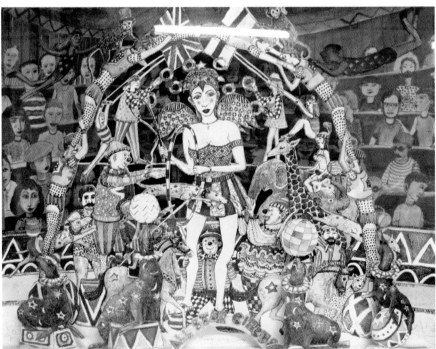

Jump, Baby, Jump, Mick Davies, 2008. 3D Photo-etching construction on foam board, hand-coloured.

WHY DO WE DO IT?

Coming to the end of this book, I realise there is no need for a conclusion, only more possibilities.

I have tried to combine basic descriptions of how many techniques are used and how they can be combined together. There are too many printmaking permutations to ever hope to gather them all together in a single book – which is what I love about printmaking. I have been making prints for as long as I can remember now; and I love making them. It is a constant wonder to me every day, that I have the opportunity to do this.

I am constantly learning about printmaking every time I interact with it. Working with colleagues and getting involved with new projects reinforces in me what I do know, but it also instigates excitement about finding out something new and challenging.

And printmaking is exciting. It is what you make it, but I believe that skills and knowledge are powerful tools. When you teach and are taught that those skills and knowledge are worth having, you are in a rare and valuable situation.

Printmaking is a remarkable way to communicate.

Skippers Hill Prep School students experience the excitement of making their first drypoint.

Printmaking is a remarkable way for us as artists to communicate and use our own initiative; which means having the confidence to trust our own ideas. This is central to what I have tried to present in this text about Hybrid Prints. Printmaking is about combining a whole host of fantastic elements.

Affordable Art Fair, Battersea, London offers both artist printmakers and punters alike a fantastic opportunity to view and ask questions about why and how a print is made.

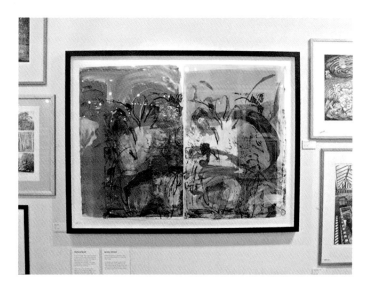

Originals Contemporary Printmaking Exhibition at the Mall Galleries, London. Printmakers value exhibition venues of high professional standards.

"The best thing about printmaking is the camaraderie in the workshop. Shared responsibilities." This is a wonderful truth about printmaking, spoken to me by the artist John Hoyland when I visited him in his studio, with which I whole-heartedly agree. Fellow printmakers in the studio are not only like-minded creators, but are an extra pair of eyes in our pursuit of the next step forward in our ideas.

Friends and colleagues and taking pride in your craft; yes, it is okay to do something well, no matter how humble you may feel your skill is. These things are vital, most importantly because they add the vitality to why we do it. Equally relevant, though more sobering is the necessity of creating a means of financial gain; at any level, professional, hobby, curatorial, studio or gallery situation, earning a living and achieving positive creative goals are a core part of our survival in the world. So, exhibit your work, join a printmaking studio, or sign up for a printmaking course! Do them all.

It is that energy and enthusiasm that will keep printmaking thriving and surviving.

Colleagues in the printmaking studio make it all worth while. Artist printmakers Melvyn Petterson and Colin Gale, Diectors of Artichoke Print Studio, London.

Being a printmaker is a life-long passion and commitment. The artist/author with one of her favourite etching presses at Artichoke Print Studio.

GLOSSARY

Acid
a strong corrosive liquid used in the etching process. The two most common acids are nitric acid for biting zinc and steel plates and ferric chloride used for biting copper plates. It reacts with the surface of the metal and creates fumes, hence it must be used in a covered tank with an extractor fan. It is also used in stone lithography.

Acetate
clear thin mylar or plastic used for making stencils, or for registration, or as a surface for outputting inkjet images from a printer.

A la poupée
a method of inking a plate with more than one colour of ink. The colours are inked and scrimmed individually onto the plate one at a time. They can be deliberately blended to create mixed colour areas.

AP
Artists' Proof. 10% of the edition.

Aquatint
an etching technique in which a resin-like dust is added to the plate by heating it onto the surface of the plate. The acid only bites the plate in the areas between the dust particles thus creating a tonal value on the plate. The amount of time that the plate is left in the acid dictates the darkness of the tones on the plates.

BAT / bon à tirer
the good pull. The proof that the printmaker commits to and signs that confirms the edition will look as the image does in the Bat.

Baren
a Japanese tool usually large, circular or oval shaped and covered in bamboo used for hand burnishing.

Bevel
the angle that is filed onto the edge of an intaglio plate before printing it. The angle is usually 45 degrees. This ensures that the sharp 90 degree edge of the plate does not cut through the printing blankets on the bed of the press. It also allows the edges to be easily cleaned and wiped free of unnecessary ink that will dirty the printed emboss of the image.

Biting /bite/ bitten
the 'action' of the acid on the surface of the metal plate when it is in the acid bath.

Biting time
how long a plate is left in the acid to be 'bitten'. [See biting].

Block
printing surface referred to in relief print such as the lino block, wood block, end grain blocks.

Burin
a tool used for engraving.

Burnisher
a smooth curved tip tool used on metal plates to polish an area that has been removed by a scraper. A burnisher can be used to highlight an area within an area or to lighten an area that is too dark.

Burr
the wisps of metal that a drypoint needle pulls up when it is drawn through and into the surface of a metal

plate. These edges of torn metal hold the etching ink and create a dramatic line. It is extremely delicate and wears away quite quickly, as the pressure from inking and printing the plate causes the metal to wear away. Drypoint editions are quite limited.

Carborundum
grit used to regrain stones on stone lithography. Also used with an adhesive such as pva, to create texture on collagraph plates. Grit comes in different grades: usually fine, medium, coarse and extra fine. The grade refers to the size of the individual grit granules.

Chip board
(see MDF.)

Collagraph
a print made from a block or matrix on which collaged materials with texture have been glued. The matrix is then sealed with shellac and dried before printing.

Collograph
a photographic process.

Copper
a metal used for intaglio processes. It is available with a polished surface. It lends itself well to clean, even, width lines due to the way the ferric acid bites into the surface. Aquatint on copper is a joy. The biting times for using copper whether with lines or aquatint are much longer than for zinc or steel.

Counterprint
offsetting the printed image onto another printing surface by placing that surface directly on top of the first printed surface.

Drypoint
the techique where only a needle with a sharp tip or roulettes are used to make marks in the surface of a metal plate. No acids are used when making a drypoint.

Drypoint needle
a metal tool with a sharp tip used to make marks in the surface of metal. The movement of the needle across the surface of the metal creates a mark which has a characteristic trait called a burr. (See burr.)

DPI
dots per inch. The resolution of a digital image which is crucial to the quality of the image when it is outputted.

Driers
additives such as magnesium powder or cobalt driers to quicken the drying time of printing inks.

EPS
Encapsulated Post Script. A digital file format used to transfer graphic images within compatible applications.

Emboss
a raised design created when damp paper is pressed onto the surface of a matrix that is passed through a printing press.

Engrave
an incised mark made with specific tools on a block such as copper or fine grained wood. No acid is used.

Etching
intaglio process in which an image is created on a metal plate using acid. The plate is first covered with an acid-resistant ground or varnish. Lines or textures are then drawn on the plate.

The exposed metal from the drawn areas are what the acid 'bites' (see biting/bite/bitten).

Etching blankets
felted and tightly woven wool cloth that is cut to size to fit the bed of a printing press. A standard set of printing blankets contains one swanskin (the thick woolier top blanket) and two fleeces (thinner more smooth grained felts). They help push the dampened printing paper into the grooves and lines of the etching plate.

Extender
a carrier for ink. It is transparent and has no colour pigment. It creates a less intense version of the full strength ink colour. It does not change the density of the ink, e.g. it does not thin the ink. (See thinners.) Also known as transparent white.

Ferric chloride
an alkaline solution for biting copper etching plates. It can also be used for zinc and aluminium if mixed to the correct ratio. It has no fumes.

Gesso
a mix of plaster of paris and glue used to create texture on a matrix. Also called acrylic matt medium or primer. Excellent for collagraphs for applying and creating textures.

Gauge
the thickness of metal or wood. Metal plate is best at 1.6 mm or 2 mm thickness. Wood is best at 2 mm thickness.

Gouge
tools with v-shaped tips used for woodcut, lino or engraving.

Ground
grounds can be hard, soft or liquid. They are used to protect the surface of etching plates and to cover the surface of a plate so that an image can be drawn or impressed into them. They are wax-based or ashphaltum (tar) based.

Gum arabic
a natural material sourced from the acacia tree used in lithography for processing the image on a plate or stone.

Hand burnish
printing without a press, with a baren or wooden spoon using the pressure of your hand.

Hotplate
a metal surface with a heating element underneath. The temperature of a hotplate can be adjusted to suit both hard and soft grounds in their application to the surface of plates. A soft ground uses a cooler temperature than a hard ground, to be applied to a plate.

Intaglio
printing processes which involve using metal plates, printing inks, cutting tools, grounds and varnishes, acids and a printing press. The image is made by pushing ink into the lines and textures on the plate with scrim and then wiping the plate to a desired inkiness. Damp paper is placed over the plate and it is rolled through a printing press with etching blankets.

Jigsaw
a power tool used for cutting metal plates into shapes, and also to cut wood.

Letterpress
a process of relief printing with metal or wooden type set into blocks of text.

Lino/ linocut
A matrix on which the image made is cut into a linoleum tile block.

Matrix
the chosen foundation on which the printmaker chooses to make the print, e.g. wood, metal or card.

MDF
medium density fibre board. A manufactured composite wood-base. Similar to chip board, except with a much finer smoother grain. It is available in different thicknesses. Like metal it has thickness. (See gauge.)

Metal
zinc, copper, steel, aluminium.

Methylated spirits
denatured alcohol. A solvent used for aquatint resin removal. Also to remove button polish, shellac, French polish and permanent marker pen.

Monochrome
a single colour used in a printing design.

Monotype
a unique one-off print made by printing on an unmarked surface of metal, acetate or thin perspex.

Monoprint
commonly acknowledged to be a unique print taken from a printing matrix with has a marked surface which remains unchanging in the image though each inking of the plate is done to deliberately create a unique variant.

Mordant
dutch mordant. (See acid.)

Mr. Muscle
a heavy duty, bio-friendly kitchen cleaner suitable to use in the printmaking studio for cleaning inks, plates, worktop surfaces and silk-screen meshes and squeegees.

Nitric acid
HNO^3 mixed with water to etch copper and zinc. You can create diluted solutions of different strengths. It is also used in lithographic etches.

Offset
an image printed from a key plate then offset via a roller onto a second printing matrix. This makes it possible to print the drawn image the same way round as when it was drawn and not in reverse.

Open bite
a process in etching where in biting the plate a large area is left exposed to the acid without aquatint or with disregard to the biting time. Unexpected shapes and marks are created in these open areas.

Nap roller
a leather roller used for roll-up black ink in lithography. Roll-up black ink is non-drying. Hence the nap (meaning the raised hairy underside of the leather) roller is ideal, as the hairs of the nap roller are easy to revive in the rolling up process.

Perspex
thick acrylic sheeting used for drypoint. It also makes an excellent cover for fume cupboards for acids.

Piezo
a piezo inkjet head or nozzle differs from a traditional thermal inket nozzle or inkjet head in the way that it pulses or creates the necessary pressure to

produce the ink as a droplet. Piezo inkjets work on the principle that droplets of ink fluid are forced from the nozzle via an electric pulse rather than a heated element. This means you can have a greater variety of ink cartridges in the printer printing your image; six or eight colours at the same time instead of only four.

Photo opaque
an opaque liquid used to paint out negatives in photography. It can be used as sugar lift. It is also used for drawing opaque images on transparent matrixes for photolithography.

Planography
another name for lithography. Also applies to photo-plate lithography.

Plate
general term for the matrix in a printmaking process. (See matrix.)

Power tool
any electric tool such as the jigsaw, drill, soldering iron or sander which can be used on a variety of matrixes to mark and shape them.

Polymer plate
a plate which has a light sensitive emulsion, or light sensitive film coating on its surface which can be exposed to UV light or sunlight using positive artwork.

Pritt stick
a water-based adhesive used for adhering one paper shape surface to another paper surface. Commonly used for *chine collé*. Fine wallpaper paste or decorators paste is also suitable for this process. (See also, rice paste.)

Proof
the trial or working impressions taken in the process of making a plate. They are called State proofs. Artist proofs are the proofs allowed to the artist. They are usually 10% of the agreed edition number.

PVA glue
water-based glue, thinner than wood glue and thicker than pritt stick.

Registration
the means by which the paper and printing block are accurately aligned for the precise fitting of all shapes and colours in the image.

Relief
print made by taking an impression from a matrix in which only the upper surface of the matrix has been inked.

Rice paste
a water-based paste used for *chine collé*.

Roulette
a tool with a spinning wheel tip which is textured with fine lines or dots. This creates textured areas on a plate when it is rolled across the surface.

Scrim
also known as Tarlatan. A starched loose mesh of muslin-type material used for wiping the excess printing ink off of etching plates.

Shellac
methylated spirits based varnish for sealing the surfaces of card or wood. It is also used as a coating in lift grounds/sugar lifts and as a protective coating on metal plates in the etching process.

Squeegee
rubber blade attached to one side of a length of aluminium or wood used to push printing ink through the mesh of a silk screen.

Steel
a metal used for intaglio processes. It is a coarse metal and has a heavy surface tone which makes it ideal for colour etching. The biting times for steel are similar to zinc.

Soldering iron
a tool in which the heated tip is hot enough to melt soft metal flex or burn wood to create alternative marks on a printing matrix.

Stencil
stencils are designs cut from paper, acetate or thin card and applied to a plate, block or screen. Ink is then applied through the open areas of the design. The uncut areas of the stencil act as a suitable barrier or mask.

Stop out varnish
a thick liquid-like ground which is painted onto an etching plate to protect it from the acid. White spirit is used to thin it and remove it.

Thinners
are additives which thin or dilute, such as water for water-based inks. Oil-based inks are thinned with copperplate oil (thin, medium or thick) linseed oil, turpentine and white spirit.

Whiting
chalk (think White Cliffs of Dover) calcium carbonate in powder form used to degrease intaglio plates. Usually used in combination with a dilute solution of ammonia to create an effective degreasing solution. Also, a coating for the hand during hand-wiping of a plate.

White spirit
a solvent which is used for cleaning ink from plates and removing grounds and stop out varnish. Use gloves when handling it.

Woodcut
a print made from wood that has been cut as plank length. Example: plywood or composite board such as MDF or hardboard. The surface is cut and it is commonly printed using the relief printing process.

Wood engraving
a print made from the endgrain or crossgrain of a hardwood such as apple or boxwood.

Zinc
a metal used for intaglio processes. It is usually highly polished and is suitable for clean sharp images if a sharp black line is desired. It is ideal for aquatint as the biting times for zinc are extremely short compared to copper.

SUPPLIERS

John Purcell Paper
15 Rumsey Road
London
SW9 0TR
Tel: 020 7737 5199
www.johnpurcell.net
Fine art paper merchant.

R.K. Burt & Co
57 Union Street
London
SE1 0AS
Tel: 020 7407 6474
www.rkburt.co.uk
Fine art paper merchant.

Intaglio Printmaker
62 Southwark Bridge Road
London
SE1 0AS
Tel: 020 7928 2633
www.intaglioprintmaker.com
General printmaking suppliers, inks,
rollers, sundries etc.

T.N. Lawrence
Mail order and Hove shop
208 Portland Road
Hove
Sussex
BN3 5QT
Tel: 01273 260260
www.lawrence.co.uk
General printmaking suppliers, inks,
rollers, sundries etc.

Cornelissen
105 Great Russell Street
London
WC1V 3RY
Tel: 020 7636 1045
www.cornelissen.com
Tools, inks, quality pigments and
copper plate oils.

Richards of Hull
Unit 1
Acorn Estate
Bontoft Avenue
Hull
HU5 4HF
Tel: 01482 442422
www.richards.co.uk
Tailor made acid baths, sinks,
ventilation and extraction units.

Art Equipment
3 Craven Street
Northampton
NN1 3EZ
Tel: 01604 632447
Hotplates, etching presses, aquatint
boxes, tailor made acid trays, sinks and
fume cupboards.

Artichoke Print Workshop
Unit S1, Bizspace
245a Coldharbour Lane
London
SW9 8RR
Tel: 020 7924 0600
www.artichokeprintmaking.com
Suppliers of etching blankets and the
KB etching press. Editoning services
and tuition. Open access studio.

Mati Basis
13 Cranbourne Road
London
N10 2BT
Tel: 020 8444 7833
Steel facing copper plates.

Smiths
London Metal Centre
42-56 Tottenham Road
London
N1 4BZ

Tel: 020 7241 2430
Copper sheet.

W&S Allely Ltd
PO Box 58
Alma Street
Smethwick
West Midlands
B66 2RP
Tel: 0121 558 3301
Copper and aluminium sheet.

Antique Machinery Removal [AMR]
Tel: 01539 736111
www.amremval.co.uk
Press engineers and movers.

Harry Rochat Ltd
15a Moxon Street
Barnet
Hertfordshire
EN5 5TS
Tel: 020 8449 0023
www.harryrochat.com
Press engineers and manufacturers.

Rollaco Engineering
72 Thornfield Road
Middlesborough
Cleveland
TS5 5BY
Tel: 01642 813785
www.rollaco.co.uk
Press manufacturers. Suppliers of
rollers, tools and inks.

Daler Rowney
P.O Box 10
Bracknell
Berkshire
RG12 8ST
Tel: 01344 461000
www.daler-rowney.com

screenprinting system-base and acrylic
paints.

Framework Picture Framing
5-9 Creekside
Deptford
SE8 4SA
www.arthub.org.uk
Large-scale, quality, professional
framing facility.

G N Hughes Framing
Unit 6
36-38 Peckham Road
London
SE5 8QT
Tel. 020 7703 3182
Bespoke framing par excellence.

The British Museum
Great Russell Street
London
WC1B 3DG
T. 020 7323 8000
www.britishmuseum.org
Inspiration and exploration. The Prints
and Drawings collection is the best in
the world. Go see it!

Sun Chemicals
Bradfield Road London,
E16 2AX
Tel: 020 7473 9400
www.sunchemicals.com
Printing inks for screenprinting and
lithography.

Sericol
Tel: 01992 782619
www.sericol.co.uk
Everything for screenprinting.

INDEX